ROBERT RICHENBURG

THE RICHARD ZAHN COLLECTION

SIDNEY MISHKIN GALLERY, BARUCH COLLEGE
135 East 22 Street, New York, NY 10010, 212-802-2690
September 28 - October 27, 2006

OPALKA GALLERY, THE SAGE COLLEGES
140 New Scotland Ave., Albany, NY 12208, 518-292-7742
November 5 - December 18, 2006

inside cover: *Rotunda,* 1969
typing paper and rods, 5' x 4' x 4'
photograph by Richard Zahn

Book design by Katie Leonard

Reproductions photographed by
 Regina Cherry
 Jeffrey Sturges

Published by the National Arts Education
Foundation

To be true to myself, I had to try to find the most powerful way to get an image, to do it differently each time, this way, that way.

-ROBERT RICHENBURG

CONTENTS

Richard Zahn is much more than a devoted collector of the works of Robert Richenburg. The relationship between the artist and the collector has extended into a deep and meaningful associatation. Zahn has, in the truest sense, acted as this remarkable artist's patron—offering not only support but devoting a great deal of care and attention to studying, discussing, and questioning the artist's work. Zahn has learned to understand and appreciate Richenburg's many moods and insights and the remarkable variety of his artistic expressions over the decades.

Richard Zahn has cultivated his relationship with the artist as one might lovingly tend a rare and treasured plant. Richenburg, in turn, has always been receptive to Zahn's explorations into the artist's muse. Albert and Muriel Newman, Walter Chrysler, Joseph Hirshhorn, James Michener, and Fred and Marcia Weisman, were among Richenburg's many collectors. Still no one was more assiduous than Zahn in following Richenburg as he dealt with new and different modes of expression, as well as many different media —including painting, drawing, sculpture, and even assemblage and constructed devices. At times, Richenburg's art reflects the bleak terror of modern warfare. At other times, his body of work can suddenly shift to imagery immersed in a fanciful dream world. Effortlessly moving from one novel approach and medium to another, Richenburg was generally ahead of the work of his colleagues and often pursued risky or uncomfortable avenues with memorable results.

Richenburg was indebted to many teachers and role models from different parts of the art scene including Amedée Ozenfant, Hans Hofmann, George Grosz, Reginald Marsh, Marcel Duchamp, and Paul Klee. On the other hand, Richenburg's focus has always been on finding new ways of making art. Zahn continues to be fascinated by what both the artist and the collector view as an ongoing search for the ever shifting avant garde, as the ultimate freedom of artistic expression.

Louis Newman
Director, David Findlay Jr Fine Art

ACKNOWLEDGEMENTS

This project would not have been
possible without the enthusiastic support
of Robert Richenburg and Richard Zahn,
as well as the following people:

Dallas Dunn
Natalie Edgar
David Findlay Jr
Calvin Goodman
Bonnie Grad
Helen Harrison
Jim Jordan
Margaret Kerr
Sandra Kraskin
Ellen Landau
Katie Leonard
Thomas McCormick
Robin Radin
Irving Sandler
Gary Snyder
Jim Richard Wilson
Julie Zahn
Robert Zaller

Robert Richenburg's journey as an artist has been an adventurous one. He rose to fame as a painter of the New York School in the late 1950s, but his work was not often shown from the mid-1960s through the 1970s. Since then, interest in his paintings, sculptures, and drawings has grown steadily, and the range and depth of his accomplishment have become particularly clear in the last decade. It takes time for the world to catch up with its visionaries.

Much of the credit for this renewed attention can be given to the art historian Bonnie L. Grad, who organized a Richenburg retrospective at the Rose Art Gallery at Brandeis University in 1993 and wrote an insightful essay about his career that helped to bring a major body of work back into the light. An exhibit followed at the Pollock-Krasner House and Study Center in East Hampton in 1994, and he had his first one-man show in decades in New York City in 2001, at MB Modern. Since then, David Findlay Jr. Fine Art has shown his work regularly.

"Robert Richenburg: Abstract Expressionist"
Rose Art Museum, Brandeis University, 1993

While some artists settle into signature styles and stop growing, whether out of financial worry, loss of heart, or lack of vision, Richenburg never forgot that to be an artist is to be an explorer. His relentless curiosity led him to try out completely different ways of painting, and to use many different mediums; he has consistently challenged our notions—and his own—of what constitutes art.

In America, an artist such as Richenburg is a walking paradox. He embodies the American notion of virtue by working hard every day of his life, yet he confounds us by failing

Gouache paintings by Robert Richenburg,
Pollock-Krasner House, 1994

"Robert Richenburg," David Findlay Jr Fine Art,
New York, 2004

to focus all of his energy on a single route to "success." He did find temporary artistic fame in the 1950s and 1960s, and was an early member of the legendary Artists' Club on Eighth Street. He enjoyed the camaraderie and the intellectual stimulation that the New York scene provided, but he was not inclined to codify art; he valued growth over acceptance.

Richenburg's failure to find lasting satisfaction in a single mode of artistic expression may have helped to isolate him from that part of the art world where categories and labels are important, but it allowed him to take risks, to venture into new places, to anticipate the kind of paintings that other, younger artists would produce years later, to acclaim, when everyone's eyes had adjusted. "All my life I've gone from one thing to another," Richenburg has said. "If you make something that is avant-garde, it is ahead of its time when you make it, at that moment. It is avant-garde to other people, but not to you anymore. So I went from one painting to another because there is always the question of trying to make it stronger and deeper. It's a matter of intensifying the images. To stay with one way of painting for the rest of your life seems insane to me. Maybe it translates into success and you can put money in the bank. But you're no longer an artist; you're a merchant." The reason he makes art, Richenburg says, is to "make something that you didn't know about before, and when it's done, it becomes new to other people." It is that newness—the sensation that ground is being broken—that draws viewers to the work.

Yvonne Thomas, Robert Richenburg, Mary Abbott, 2002

Painters paint and writers write and musicians make music out of some need for expression, and whatever its psychological root, the work becomes an end in itself. The artist transcends mortality–kills time–when he is at work. The work of art is a record of its own creation. Richenburg came of age in a time when much attention was placed on that notion, a time when the artist was viewed as an existential hero. This all seems a bit quaint today, when you consider that the exemplars of the heroic struggle, Pollock and de Kooning, spent much of their time fighting off alcoholic withdrawal, but it was a big step in the direction of marketing painters and painting. The loudest critics of the day, Harold Rosenberg and Clement Greenberg, championed the artists of their choice as if they were their own heroic creations, helping to invent and articulate an aesthetic creed for struggling men, and a few women, whose work was known by a few hundred people at most.

The parallel that has often been drawn between Abstract Expressionist painting of the mid-20th century and the improvised music we call jazz is at best imperfect when applied to the movement in general, but it applies with startling precision to Richenburg's work.

Improvisation is fleeting; its beauty lies in its evanescence, which is why live jazz performances can be so much more compelling than recorded examples. The genius of some jazz artists, according to their colleagues, was only rarely preserved on record perhaps because of the technological limitations of the day or because of the musician's discomfort with or dislike of the recording process.

Marggy and Bob with grandchildren, Kaley, Zach, Christmas, 2004

Many jazz musicians think through their improvisations to at least some degree. Louis Armstrong worked out his famous solo on "West End Blues" before playing it, and others use clichés, in the musical sense of the word, to get them from one chorus, or phrase, to the next. Others, however, such as Lee Konitz or Sonny Rollins, maintain that the music only matters when it is being made up on the spot; without the element of risk, they say, the music doesn't have life. Thelonious Monk refused to play his tunes more than once or twice in the recording studio because to repeat them would kill the spontaneity. If Monk's sidemen missed a note, if a saxophone squeaked in mid-phrase, it would be preserved forever on the disc. It was considered better to risk failure than to repeat yourself. To paraphrase Blake: without the obstacle, or opposition, presented by that kind of pressure to create, there can be no progress. To watch a film of the clarinetist Pee Wee Russell struggling to say something new–and succeeding–in each bar of a 12-bar solo, while, a few feet away, fellow masters such

as Coleman Hawkins, Vic Dickenson, and Roy Eldridge listen—is to be present at a moment of true artistic invention.

Richenburg more than that of most of his contemporaries hews close to the Konitz-Rollins definition of the creative process. This is the fundamental premise upon which his art is based. Further, Richenburg worked in the hope that the painting would finally take over from him. His contemporaries in other genres worked much the same way. The novelist Thomas Berger has said that he never knows what will happen next in one of his books as he is writing it, and that once he has attained a kind of momentum in his work, the characters seem to tell the story for him, of their own volition. Sonny Rollins has said that when he is playing very well, he is unaware of thinking, or of the motion of his fingers on the saxophone's keys; the musical ideas come from outside him.

The artist at "Robert Richenburg: Abstract Expressionist." On wall: left, *Disintegrate*, 1959, right, *Sign of Darkness*, 1959-61. Photograph by Ken Spencer.

Pollock famously spoke of being one with nature; he said that once he established "contact" with the creative force, the painting flowed through him. Richenburg sought such contact, and we sense its presence in his best work just as we sense it in "Autumn Rhythm," or in the rolling choruses of a Bud Powell piano solo.

"You always have to have some idea to start with. And then it takes over," Richenburg says. "It begins telling you what it needs, rather than you telling it. This may sound rather foolish, because I'm the one making the painting, but that was how it worked." In the case of one of the black paintings of the 1950s, "I started by putting the canvas on the floor and throwing paint onto it. After a while, that didn't work, so I painted it over with black. Then I started scraping away the black paint to find the image beneath, and still it didn't work. So I added black circles and rectangles, because it needed something, and in that process I suddenly found it. This is an image of death—the death of a person. A figure appeared: two legs, a head. I didn't intend for there to be a figure; the painting told me."

Richenburg's understanding of the creative process differs dramatically from that of Mondrian, for example, another painter whose work sometimes is compared to jazz. While the titles of the famous "Broadway Boogie Woogie" and "Victory Boogie Woogie" refer to a form of popular improvised music, the paintings refer visually to the pattern of lights in Times Square, which Mondrian associated synesthetically with music. The paintings themselves are wholly premeditated, and are closer in spirit to Bach than to Sidney Bechet. In this sense, it is Richenburg,

not Mondrian, who is avant-garde.

De Kooning worked on the fly yet he always had a point of departure—he acknowledged that every good painter needs an arsenal of tricks, like a musician's clichés, to get from one part of a canvas to the next. Even the drawings he made with his eyes closed were made with the figure of a woman in mind.

But de Kooning, like Pollock, worked to reach the trancelike condition that allowed his subconscious to take control of the painting process, and it may be for this reason that even his late paintings, made when he was mentally impaired, have such a startling freshness. They are like "listening to jazz on the telephone," one critic wrote. Though there may be something of a screen of mystery between the viewer and the artwork, the improvisational nature of the work is still apparent.

The surprises in Richenburg arise out of improvisation and also out of what seem, in retrospect, to have been epiphanies. These startling moments pop up in works from the 1940s that have appeared in an earlier Richenburg survey, but they bear examination here as instances of foreshadowing.

The restlessness that is evident in Richenburg's early work is of course an indication of a young artist's search for a style of his own. What is perhaps most remarkable is Richenburg's search for a way to convey both inner and outer worlds. A kind of Richenburg reader, these early works teach us how to look at his pictures. We become familiar with his iconography and some of his techniques, and we become acutely aware of their often mysterious emotional content. The vocabulary he used in the 1940s will prove to be the basis for everything he produced from the 1950s to the present, and on that level alone these works are fascinating to see.

Many painters of the Abstract Expressionist period came to rely on one or more templates—the tic-tac-toe grid and alphabet soup of pictographs, the biomorphic blobs of figural abstraction, the inscrutable edge and void of color field painting. Although identifiable and powerful styles did arise from those experiments—and it was a time when experimentation was highly valued, or at least was much talked about—many painters, having arrived at one style, stopped there, whether due to fatigue, narrowing vision, or loss of heart. But Richenburg found a way through.

Like de Kooning, Richenburg thought of painting as a blue-collar job. He has said, in his matter-of-fact way, that frustration played a major role in his own day-to-day method of working. Again, like de Kooning, he always struggled to get it right, or at least to get closer to some idealization of painting, when other artists simply called it a day. And he knew that once he started feeling comfortable, or had reached a dead end, he was no longer making art, and he was willing to try anything to get back on track.

Because of his curiosity and restlessness, Richenburg made wholly distinctive pictures that even today can be mistaken for no one else's even as he was drawing accomplished but fairly conventional landscapes and portraits in his notebooks. In the 1940s, he managed to anticipate fashions of the 1960s and 1980s such as Pop and Neo Geo. In Richenburgs of 1946 we find Gerhard Richter. Everyone goes around saying it, but it is only when we look at a picture such as "Twelve O'Clock Blink," with its hot and cool polka dots in a scrubby gray field, that we remember that there is indeed nothing new under the sun.

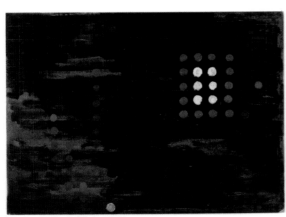

Twelve O'Clock Blink, 1946
oil on cardboard, 7 1/4 x 10 1/4 inches
Collection of the artist

Richenburg has often insisted that once the "rhythm" of a picture is established - once he has "made contact" with the picture, as Pollock put it - the battle is half won, and he can keep working with some hope. But Richenburg found that rhythm not only through automatism but by more artificial means. Only Mondrian managed to combine intellectual and painterly concerns as vividly as Richenburg did in his pure rhythmic abstractions.

As early as the 1940s his pictures have the atmosphere of riddles, and it is in the attempt to solve them that we become engaged, as we do in understanding poetic metaphor. Riddles are, after all, just metaphors waiting to be completed. What you bring to the riddle determines whether you will be able to solve it. But one of the wonderful things about these pictures is that we sense that the artist is trying to solve the same riddle that we are; his adventure in making art becomes our adventure in viewing it.

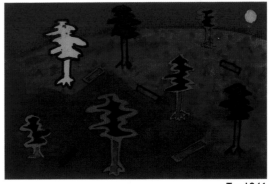

Try, 1946
gouache on paper, 4 1/4 x 6 3/4 inches
Collection of the artist

Sketches he made on a camping trip in the Sierras in 1940, the year he turned 23, and drawings from a subsequent tour of duty in the Army, in Europe, as well as a Cubist-Futurist head, are for the most part just what we expect to see from a talented young artist, but there are drawings too that hint at Richenburg's tendency to find highly personal symbols in nature. That interest is at first a formal one, but it becomes emotionally evocative when he moves from drawing to painting. A pencil drawing from 1943 of a stretch of countryside with trees is fairly straightforward. But nature seems to have been tampered with; we aren't quite sure why some of the trees are down, so a

Second Try, 1946
gouache on black paper, 5 1/2 x 8 1/2 inches
Collection of the artist

question hangs in the air. This is just a hint of what will follow just three years later, in a pair of highly artificial landscapes.

In each of these 1946 gouaches, we see seven trees, separated by five bars of color that resemble planks. The treetops are blobby, nervous amoebas, like Christmas trees drawn by a six-year old. In the first picture, the treetops are red, white, black, orange-pink - colors like poster paint. Their vividness, and the isolation of the trees against bright grounds, produced the kind of vibration that can be found in later works such as "Face to Face," where the artist seems to have plugged his brush directly into an electrical outlet. In the second picture, the same trees, identically positioned, are outlined in bright colors but filled in with green or gray or white. The alternatives are intriguing, and give us a taste of Richenburg's capacity for mystery.

More than once, we are struck by imagery that seems to have been drawn from a dream or nightmare. In particular, there are the strange creatures, each isolated on a little archipelago, in the "Ecce Homo" studies. Sometimes these beings—harpies, mutated bats, the denizens of bad dreams and unfriendly planets—are connected by sticky black threads of paint and sometimes they stand alone. They are arranged in orderly rows that recede unpleasantly to the horizon and perhaps beyond it.

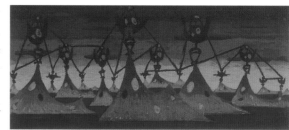

Study for Ecce Homo, 1946
gouache on paper, 3 3/4 x 7 5/8 inches

Sometimes they resemble unicyclists on tightropes; sometimes they are illuminated by a red orb that could be the sun and could just be a formal anchoring device.

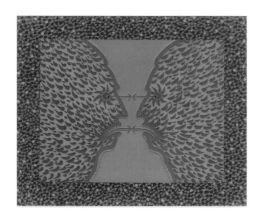

Face to Face, 1979
acrylic on paper, 23 1/2 x 29 1/2 inches

That orb shows up in a number of Richenburg's pictures, holding down a corner of a composition or burning in a black sky, and after a while it comes to seem emblematic of a kind of assertiveness. Although his approach to a picture is always changing, that insistent quality remains, underlining the serious nature of his commitment. We understand from as early as 1945 that this is a painter with a particular vision, and no matter how simple his images, they are always presented empathetically.

Richenburg surprises us, too, by striking emotional chords in ways we had not anticipated. The works of the 1940s tap into the viewer's subconscious in subtle

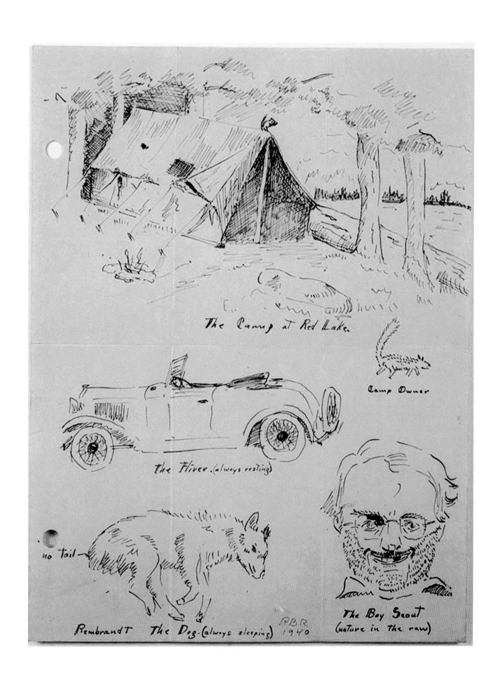

The Camp at Red Lake

Camp Owner

The Fliver (always resting)

no Tail

Rembrandt The Dog (always sleeping)

RBR
1940

The Boy Scout
(nature in the raw)

Rembrandt the Dog (The Camp at Red Lake), 1940, sepia ink on notebook paper, 10 1/2 x 8 inches

Ron Richenburg's first birthday
Fort Greene, Brooklyn, 1948

ways. Richenburg knows how to draw us into an image, and it is usually by means of that essential visual rhythm that he has spoken of. Once caught up in the rhythm, we begin to absorb the imagery. Then, something else begins to happen, and we forget about "meaning." It is rather as if some revelation were just around the corner. At that moment, we, and Richenburg, have broken clear of the boundaries of art. Such moments are extremely rare.

There is nothing convenient or orderly about the development of Richenburg's career; he tends to double back on himself or to take unexpected turns. It seems that one moment, he's painting on canvas; next, he's working with plastic or wire. Still, keeping in mind that he often took random exits off the chronological expressway of his career, we can take a journey through the mature phase of his career by beginning in 1947, when Pollock was at the height of his powers and de Kooning was just hitting his stride.

It was the time when American artists realized that they weren't necessarily inferior to the European modernists, and decided that they didn't really care what André Breton or Max Ernst thought of them. De Kooning recalled that moment of revelation, which arrived with the departure of the Surrealists who had taken up temporary residence on the East Coast during World War II. They had, for the most part (Matta was the notable exception), treated their American colleagues as if they were mildly talented children.

In 1947, Richenburg moved to New York with his wife after spending a year in Provincetown, to which he had migrated after being discharged from the Army in 1945. It was a good year; he met de Kooning and Ibram Lassaw, who was to remain a lifelong friend, and with the help of the G.I. Bill, studied with Amedée Ozenfant.

Ozenfant was 28 when World War I came to Europe, and his art, like that of the Dadaists and Surrealists, was profoundly influenced by the chaos the war produced. But while the Surrealists reacted to the absurdity of a murderous civilization with passive-aggressive absurdity of their own, Ozenfant and his friend Le Corbusier insisted that art must embody order. If the Cubists could reduce a landscape or a still life to a series of overlapping colored planes, then the practitioners of Purism, as Ozenfant and "Corbu" called their new movement, would take nature out of the picture completely. Their aim was to eliminate all reference points and associations; art should be as beautiful as mathematics, they said.

Ozenfant had a lasting influence on Richenburg though he studied with him for less than a year before making a characteristic lateral move–to work with Hans Hofmann. Richenburg was impressed by both men, and his forays into the kind of painting that would, decades later, be called Minimalism and Neo Geo, might well have their roots in Ozenfant's notions. As far as Hofmann goes, his influence was felt by such a broad range of painters that it is almost impossible to point to it in anything they produced as mature artists, though Richenburg found working with Hofmann freeing after a stint with Ozenfant.

The 1947 gouache "Study for Pregnant Woman Contemplating Flight," with its baroque title, shows us something of Richenburg's absorption of European modernism, filtered through the Ozenfant experience. This is Richenburg in a neoclassical mood; the picture has biblical overtones yet is painted in the manner of an apprentice who had spent time in the studios of Klee and Arp.

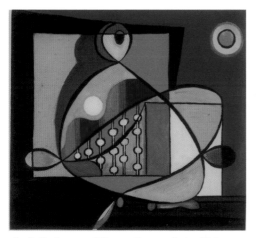

Study for Pregnant Woman Contemplating Flight,
1947, gouache on paper, 7 5/16 x 8 inches

The picture has the playful nonobjectiveness of a Klee but there is an air of symbolism; a burning red sun with a gray halo, like a wound, or the center of a target, hangs in a blue sky that reads not as sky but as color, and the female figure contains both a moon –the night–and a fragment of what could be a gate, or the bars of a Byzantine playpen, or strands of DNA. The single stylized eye at the center of the women's head is frightening, as if she were an alien creature. But as in many Richenburgs to come, it is the claustrophobic relation of shapes that lends the image its dark power–here, those shapes are boxes within boxes, airless framing devices in symbolic colors–green for go, red for stop. The woman contains a landscape as well as glimpses of an interior scene, but there is nothing that suggests escape; indeed, the figure is outlined by figure-eights, loops of black that turn back on themselves: she is literally tied in a knot. The long shadow that she casts on the green shape behind her suggests sleepless nights, and the queasy sensation of suspended time that we find in de Chirico, and that Magritte borrowed for his own tales of the subconscious. The picture's power derives from its jarring dislocations of form and its oppressive compression.

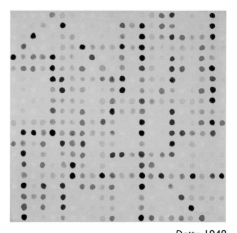

Dotty, 1948
oil on canvas, 28 x 30 inches

Nothing could be further from "Pregnant Woman" than "Dotty," one of those Richenburgs that foretell the future of painting, and a picture that you return to precisely because it represents nothing. The modest joke of its title takes on an

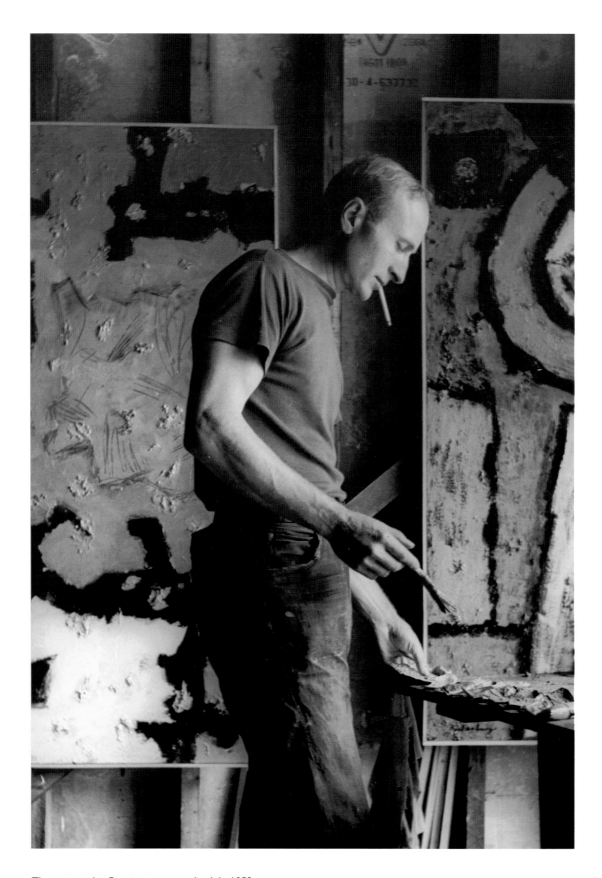

The artist in his Provincetown studio, July, 1952.
Photograph by Maurice Berezov.

odd resonance with time: just who is Dotty–the viewer, Richenburg, both? The picture gains in resonance, too, when it is compared with "Light Question," its doppelganger, a plastic construction made some 33 years later that also confronts us with neat rows of circles and begs the question of "meaning." "Dotty," painted in 1948, is based on a graph-paper-like grid of squares, into each of which Richenburg has popped a brushy little circle of color. It reads as a punch card, as a stylized map of a subway system, as a playful response to pegboard, as an unhelpful color chart. The specter of Mondrian inevitably lurks, yet "Dotty" has little to do with Mondrian, and in fact, this picture is, for all its reduction to the "pure" elements advocated by Ozenfant, wholly impure, for every dot seems to have a life of its own, and seems more than willing to pop out of its box, if given half a chance.

The painting quivers with personality; Mondrian and Ozenfant sought to eliminate much of this kind of human association.

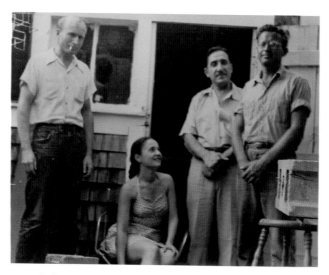

Robert Richenburg, Marcia Pavia, Philip Pavia, Ibram Lassaw at Ibram's studio, Provincetown, MA, circa 1950-53

The dots in "Dotty" are fuzzy, brushy, irregular, and their animation, both as individual images and in their relation to the big box that traps them, also has something to do with their arrangement. Patterns have been created by the artist's distribution of color–shapes like arrows, the suggestion of letters, designs that nearly assemble into faces, fragments of a figure, and of course simple geometric shapes such as ladders. But the magic of the picture resides, finally, in its resistance to our attempt to decode it. There is no code to crack, what you see is what you get, and what you see depends on what you bring to it in the form of concentration–and to what degree you can empty your mind of associations while looking at the picture. As always in Richenburg, there are no pat answers to whatever questions a painting raises; in this, he is the modernist *par excellence*, always resisting the sentimental associations of received wisdom, and it is in this that he effectively carries out what Ozenfant preached, for Richenburg is a Purist whose paintings actually have a life of their own. Richenburg took what he could from Ozenfant (and Hofmann, and Mondrian) and went on to connect the theory of Purism with the history of art in a meaningful way. Only a great painter can translate theory into something that actually affects the viewer.

By 1950, Richenburg had become friendly with many other painters of the New York School and was an early participant in the regular bull sessions and more formal presentations at the Artists Club on Eighth Street that Philip Pavia and Ibram Lassaw, among others, had founded in 1949. He showed at the Museum of Non-Objective Art, was no stranger to the ramshackle New York School temple

known as the Cedar Tavern, and, in the next six years, would become established as an important younger artist on the scene, both in New York and in Provincetown, where he spent summers.

When Leo Castelli invited him to contribute work to the Ninth Street Show, a now-legendary moment in the history of New York painting, he joined a roster that included de Kooning, Kline, Reinhardt, and other major artists. He showed in the annual exhibits of the Stable Gallery, group shows that served as indexes of New York School activity for several years, and he taught at Pratt Institute and Cooper Union. He maintained a presence in Provincetown, too, exhibiting there as well as in Philadelphia, where he had a one-man show at the Hendler Gallery in 1953. By 1957 his career would begin to accelerate even more dramatically. But 1950 was a pivotal year; he painted a masterpiece, "Clouds," which led to a series of variations on a similar theme called the "Dancing Figure" series.

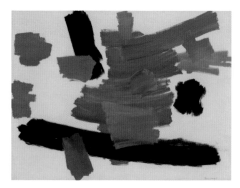

Clouds, 1950, oil on canvas, 44 x 60 inches

"Clouds" is one of those works of art that seems unlike any other, wholly invented, surprising, yet somehow inevitable. Here Richenburg's brush strokes suggest both velocity and stillness; we can track the movement of the loaded brush as it passes over the canvas, leaving patches and blotches of a bright, clear blue, red, and orange-red, yet each of the forms is suspended, weightless, and is partly transparent, like a cloud. There is evidence of the artist's hand, yet the forms seem to have arrived on the canvas as effortlessly as clouds appear in the sky, retain their

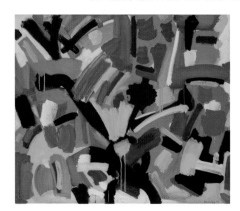

Ecce Homo II, 1950
oil on canvas, 42 x 50 inches

shapes briefly, and then turn into something else. They hang at different altitudes; some seem closer to us than others, some move quickly and some are static. Because the "sky" behind them is made of broken patches of pale yellow over white, they stand out in sharp relief. Though it is a flat abstraction, the canvas gives you the sense that you are looking up. Richenburg is re-introducing us to elementary spatial illusions, of depth and motion, and the painting is thus one of the best illustrations of Hofmann's notions about the "push and pull" of color. But its greatness lies outside color theory. We accept these clouds just as readily as we accept Constable's vaporous apparitions even though they give us every reason not to believe in them: they are the wrong color, the wrong shape, the wrong size.

The raggedy-looking brush strokes suggest impulsiveness but they seem to have been placed with extreme care. One is reminded of de Kooning's method of

working: slash and stab at the canvas, then stand back and look at it for half an hour; stab and slash, stand back. The union of stillness and motion in "Clouds" is so true to its subject (or to its inspiration, rather) that it seems as if we have always known it.

"Ecce Homo II," a large canvas, and "Royal Stomp," an oil painting on paper,

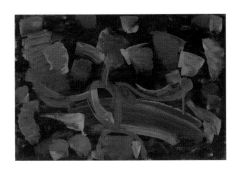

Royal Stomp, 1950
oil on paper, 12 x 17 1/2 inches

represent further adventures in a similar vein. "Royal Stomp," in particular, with its raucous title reminiscent of the kind of classic New Orleans jazz that Pollock drove his wife crazy playing over and over again, belongs to the series of "Dancing Figures," paintings meant, the artist later said, "to express the world of before-thinking."

In "Royal Stomp," the sunny sky of "Clouds" has been replaced by a black ground interrupted by patches of bright blue-white, like flares illuminating a jungle. The central figure, a rubbery stick figure, is made of a series of looping, red calligraphic strokes, and a circular pattern of orange-yellow blotches suggest that the dancing figure is juggling torches. It is a jubilant picture, as are all of the dancing figures, but it also prefigures the black pictures Richenburg made in the late 1950s. Here, darkness is redeemed by an expression of joy in dance, but the picture is suffused with darkness nonetheless. There were reasons that people danced in the jungle by firelight apart from celebration. They could just as well be confronting the unknown, exorcising fears, summoning spirits of ambiguous intent, making contact with darkness in an attempt to make peace with it. The artist has also said of the dancing figures that they show "the passion and grace of wild dance."

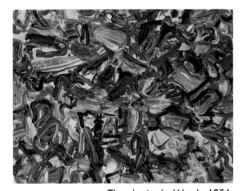

Thunder in the Woods, 1956
oil on canvas, 36 1/4 x 48 inches

In "Ecce Homo II" the apotheosis of the dance series, the atmosphere changes though the central figure remains. The ground against which the dance plays out is packed with patches and stripes of bright color that moves this way and that, echoing and amplifying the motion of the figure itself. Here, the brushy shapes of "Clouds" are jammed up against one another, a logjam of bright strokes, and the palette is noisy.

At the time Richenburg made this picture, the pictographic grid–a kind of loose tic-tac-toe board that framed mysterious, organic-looking icons, or bits of abstract calligraphy–had crested in popularity. New York School painters such as Baziotes and Rothko and Tworkov had been giving it a real workout for a half-dozen years. "Ecce Homo II" seems to be Richenburg's way of bidding adieu to this structural device by blowing it into a thousand pieces.

The picture is a welter of color that leaves us with the impression of a satisfyingly loud and clear discord, exactly as in Charles Ives. Its activity prefigures the congested composition of gestural masterpieces such as "Thunder in the Woods" and "Yellow Triangle," which would take form several years hence.

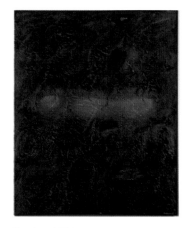

Slumber, 1951
oil on canvas, 60 x 50 inches
Collection of the artist

But it is important to remember that Richenburg, having made a satisfying picture, was just as likely to change his manner of painting completely as he was to develop a theme. And so, having turned up the volume in "Ecce Homo II," he reduced it almost immediately to a whisper in paintings such as "Slumber" and "Lactescence," which are relatively devoid of color and motion.

"Slumber," a black canvas that offers just a glimpse of a shrouded figure at its center, nods not so much to Rothko or Reinhardt (it would be convenient to view it as an excursion into Color Field painting) but to Whistler's nocturnes. It reminds at least one viewer of Bacon, and has been cited as a tribute to Goya, for its gloomy subject matter (and Richenburg loves Goya).

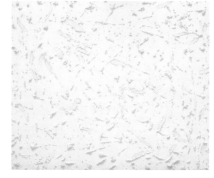

Lactescence, 1951
oil and sand on canvas, 50 x 60 inches
Collection of the artist

"Lactescence," on the other hand, is a white painting made of pigment mixed with sand—a meditation on light and nature unmediated by a concern with subject matter, as if the artist were turning away from the narcissism of "heroic" gestural abstraction and reminding us, and himself, that it is worth looking at a world unpolluted by theory and "meaning."

Richenburg is as playful an artist as Calder—witness the elegant and witty sculptures, cut from metal, that he began making in the 1970s, as well as the frottages and other improvisations on paper. Some whimsical drawings remain from the 1940s, too, and it is worth remembering that it was his cartoons that helped win him a scholarship to study art at the Boston Museum of Fine Arts. Of course, he was 13 at the time.

The playfulness of Richenburg's work is all the more to be cherished because his own childhood was, in his words, "hellish." He was traumatized by a cosmetically disfiguring accident in early childhood that would make him feel freakish and lead to recurrent nightmares severe enough for him to fear going to sleep for years. And

SCHOOL COMMITTEE OF THE CITY OF BOSTON
DEPARTMENT OF MANUAL ARTS
15 BEACON STREET, BOSTON, MASS.

HELEN E. CLEAVES, DIRECTOR
EDWARD C. EMERSON, ASSOCIATE DIRECTOR

May 7, 1931.

Mr. Robert Richenburg,
75 Augustus Avenue,
Roslindale, Mass.

Dear Mr. Richenburg:

It gives me pleasure to tell you that you have been awarded a scholarship in the Art Class at the Museum of Fine Arts for the school year 1931-32.

I am enclosing a statement from the Museum of Fine Arts which gives detailed information concerning the class.

When you report to the Head Master of the high school which you are planning to attend, will you please tell him that you have been awarded a scholarship in the High School Museum Art Class. It will be necessary for him to know this in connection with your high school program for next year.

I trust you will derive much pleasure and profit from your work in the Museum of Fine Arts.

Cordially yours,

Helen E. Cleaves

Director of Manual Arts.

CGK.

Richenburg grew up in the middle of the Great Depression. In 1933, when he was 15, he and his older brother began delivering oil, coal, and ice to help support his family, and he started his own delivery business when he was 16 for the same reason, postponing for a few years his ambition to attend art school. He worked all day and took night classes at Boston University when he was 17, and was able to begin studying full-time at George Washington University in Washington, D.C., the following year, but the oppressive poverty he and his family endured made a lasting impression on him.

1933

Richenburg delivering ice in the summer, 15-16 years old

If an artist is to spend all day in his studio every day for decade upon decade, he can't afford to be too grim, and he must find ways to keep working even when he doesn't feel like it.

De Kooning and Richenburg have both spoken of the difficulty and necessity of facing the painter's work day. Even if he only could bring himself to spend the time making frames or sweeping the floor, Richenburg went to the studio daily, as de Kooning did; it was their refuge. Early in life, Richenburg discovered that he felt comfortable when he was drawing, at a time when he felt out of place in virtually every other situation.

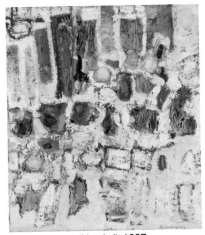

White Abstract (Untitled), 1957
oil on canvas, 28 1/2 x 25 1/2 inches

"I made it a rule to work every day, and never to spend more than 10 minutes thinking about a picture, because once you do that, you spend the whole goddamn day thinking. Usually I would go into the studio in the morning and then in the afternoon. You have to learn to give yourself up to the rhythm of the picture. Once you do that, the painting might take over, and it can paint itself. I would start with some idea, but once you give yourself up to the rhythms, that idea can change radically. It can be a marvelous experience. But sometimes it doesn't happen. In either case, you have to be in the studio, doing something, anything, maybe stretching canvases. And then something might happen."

The darkness that nearly engulfs the great Richenburgs of the late 1950s, majestic pictures such as "Syria" and "Summer's Night," is a response, the artist has said, to the darkness of the world. They are disturbing, wrenchingly beautiful and brutal in their imagery and in a method of composition arrived at by accident, in which Richenburg covered colorful canvases in black, and then scraped away the darkness to reveal bits of light, as if he were tearing a bandage from a wound in increments.

But then there are the "white pictures." "White Abstract," for example, is only partially white: it draws its power from a rickety avalanche of blocky, colored shapes that emerge from whiteness the way flaming shapes emerge from the dark in the black canvases. He is once again re-energizing the pictographic grid, but this time the images suggest an urban landscape, despite the artist's emphasis on the picture's nonobjective qualities by giving it the title he did. In Richenburg's sly way, it is as much a colorful representational picture as a white abstraction. The city's river of noise is frozen in white wintry light—it is tempting, considering the date of composition and Richenburg's sensitivity to the dark side of human nature, to think of it as nuclear glare—the world vanishing into an apocalyptic whiteout. Perhaps it is midday, somewhere around Union Square in New York.

The picture seems carved out of pigment the way that a city, viewed from above, can seem carved out of brick, stone, slate, and in much the manner that Richenburg carved light out of the darkness of his black pictures. "White Abstract" is a *tour de force* that draws on and extends pictorial traditions in a dreamlike fashion, as if the artist were channeling pure painterly energy. It gives the impression that Richenburg has made the connection with the elementary force that Sonny Rollins and Jackson Pollock spoke of. For all its singular power, we sense art history in every inch of the surface, the way we sense Ingres in every brush stroke of every woman painted by de Kooning.

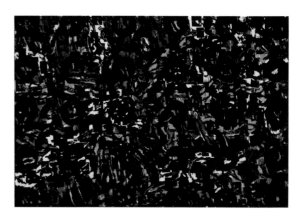

Summer's Night, 1960
oil on canvas, 96 x 132 inches
Private collection

In this one canvas, Richenburg manages (only semi-consciously) to recapitulate the visual impact of both Post-Impressionism and the sooty air of the Ashcan School painters while working in a mode recognizable as that of an Abstract Expressionist —and anticipating the rough clumsiness of Schnabel. The associations the picture provokes—not only with Whistler and Ensor and Turner but with Childe Hassam's flag pictures, and, straddling centuries, with both Giotto and the later pictures of George McNeil—are dizzying. The allusiveness of "White Abstract" is stunning—and, at 28 by 25 inches, it has the presence of a much larger picture.

"White Abstract" is as different from "Ecce Homo II" as it is from "Thunder in the Woods," a major canvas painted in 1956, the year of Pollock's death. "Thunder" reminds us that Richenburg, again like de Kooning, never stopped taking joy in the simple physical process of slathering oil paint onto canvas.

"Thunder in the Woods" and "Hurry," another important picture, made in 1958, show Richenburg at his glossiest. In each, the sheer quantity of paint and the assertiveness of the palette are enough to stop a viewer dead in his tracks. In "Thunder," the paint is pushed across a three-by-four-foot expanse of canvas in a

tangle of strokes, drags, and smears that threaten to turn into letters of the alphabet or sketchy figures. There are broad hints of the chromatic juxtapositions that lay just ahead. Although there are countless patches and twists of yellow and blue and red snaking through "Thunder," they read as glimpses—the structure of the painting is determined by black and white strokes, boomerangs and bars and calligraphy, shapes that resemble buckets or bananas, ears and steins of beer. Because black and white are often smeared together, the painting has a silvery tone. The brush work is as energetic and free as anything the artist had done before, and the image seems to extend beyond the edges of the canvas, but the picture has a magnetic center, a vortex of yellow, white, and blue, and every other brush stroke is drawn toward it. That drama is enhanced by the sense that the image has been dramatically cropped, like a detail from a forty-foot fresco; it has microcosmic power, and the painterly exhilaration of Soutine at his wildest.

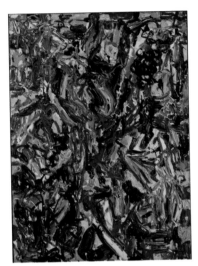

Hurry, 1958
oil on canvas, 76 x 56 inches

The exuberant "Hurry," a painting in the format of a classical portrait, is in a sense a portrait of painting itself, in the way that a John Coltrane solo is a recapitulation of the history of the saxophone. Richenburg has said that he painted as quickly as possible to see what he could "catch" on the canvas (hence its title); the picture is therefore an improvisation. But like any musical improvisation worth hearing, it is backed up by decades of work. Richenburg went to his studio and worked every day, as I have said, and John Coltrane showed up for gigs in the studio or at clubs hours before he was due; he rehearsed before playing and in the breaks between sets; he played when he got home and he played when he woke up in the morning. Whether you hear a 30-second Coltrane break or a 20-minute solo you are hearing the distillation of a lifetime's work; when Richenburg set out to paint as quickly as he could, he was simply letting his experience speak through him without intervention. That trancelike condition is objectified in "Hurry," yet it is a well-ordered picture, with a sophisticated balance of color temperatures and deeply engaging sensation of shifting depth across its surface.

The dramatically different pictorial approaches exemplified by "Clouds," "Ecce Homo II," "White Abstract," "Thunder in the Woods," and "Hurry" suggest that Richenburg was making a conscious decision to present himself to the world as a virtuoso but in fact he kept changing out of necessity. "I tried doing the same thing," he has said, "but I couldn't. When I had explored and exhausted one area, I moved to another."

What had begun as a refuge for a shy boy had turned into a reflection of the artist's whole being, and if Richenburg was self-effacing in private he was among the most assertive painters of the period, and was willing to put his reputation on the line every time he picked up a brush.

Richenburg has spoken in detail of the nightmares he experienced as a small child, which, he later realized, had something to do not only with his attraction to art but also with certain kinds of imagery in his painting; he has also said that he realized only many years after making certain pictures that they were connected, at least indirectly, to events in his life in ways that he had not consciously intended.

"Syria" is one of the series of black paintings that Richenburg began making when he found himself at a dead end of sorts, a point at which he felt he had taken the all-over gestural mode of "Hurry" about as far as he could. Rather than repeat the format, when he found himself confronting a colorful 48-by-32-inch canvas that wasn't going anyplace new—or new enough to satisfy him at the moment—he covered it in black paint.

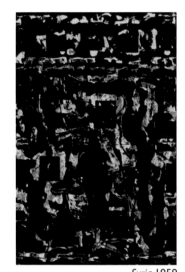

*Syria,*1959
oil on canvas, 49 x 32 1/4 inches

This series of paintings has a demonic character that is only slightly mitigated by the flashes of color that break through their dark crust. The orange, yellow, and red images that flicker there are like flames glimpsed through the vents of a coal furnace or a wood-burning stove: hypnotic, pretty to look at, but dangerous. The black pigment protects us from the painting's full chromatic force.

Richenburg was not the first of the major painters of the 1950s to work at the dark end of the spectrum. Clyfford Still made effective use of jagged ebony stalagmites, and we remember Ad Reinhardt primarily for all-black canvases. Rothko, too, used a very dark palette in some of his color field pictures. De Kooning and Kline and Motherwell made effective use of black, but they were interested mainly in its graphic impact on a white ground. Let's not forget that black house paint was relatively cheap, and with rare exceptions, none of these artists was rolling in dough.

When Richenburg used black, he meant it to have a physical and metaphysical impact—to reflect a spiritual condition. Things looked dark at the time, he said, and "Syria sounded like a dark place." Richard Zahn, who owns "Syria," remembers climbing to the roof of the firehouse in his hometown with his father and other veterans of World War II to watch for Russian aircraft in the year this painting was made; the cold war was getting hot, and everyone felt it.

Richenburg scraped away the dark pigment in little patches, arbitrarily, to see what lay underneath it. The pictorial suggestiveness of "Syria" is manifold. It has been suggested that it resembles a city in flames, seen from the air after a night bombing raid. It is a dark tapestry, a shredded cleric's robe. But the most telling analogy comes from Richenburg's own subconscious.

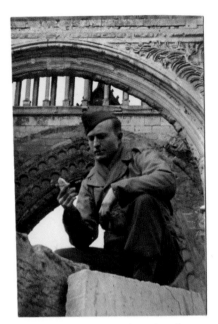

Robert Richenburg at the ruins of Soissons Abbey, France, 1945

Richenburg's ability to yoke a mature artist's powers of concentration with the restless curiosity of a child is at the heart of his work, and the playful side of his sensibility is particularly apparent in the bright experiments of his early and later periods (and would serve him well as Abstract Expressionism was eclipsed by Pop Art). But the forceful, dark pictures of the late 1950s tap into recollections of his military service as well as actual nightmares.

As a combat engineer—an expert in demolition—he spent three years in the company of explosives, training soldiers in England and France in the use of mines and booby traps. Richenburg has spoken of the dread he felt when he was guarding the explosives, on guard at night "pulling in the immense, haunting blackness around me, becoming one with it." One night, he "heard peacocks shrieking, making noises that sounded like humans screaming. That night was filled with terror."

The waking nightmare of the war was superimposed on a recurrent nightmare of his childhood. When he was 2 years old, a pot of boiling tomatoes spilled, scalding one side of his head. The scalding incident was transformed into a nightmare of an inferno. "For the next few years I would wake up screaming night after night. I used to hate to go to bed."

The dream recurred through his teenage years, and a scar left by the scalding—a large bald spot on one side of his head—alienated him from others. "It absolutely haunted me through childhood. I always felt like a freak, outside the normal. I had to comb my hair a certain way to hide the bald spot, and hope the wind wouldn't blow. I always turned my head a certain way when speaking to people. My family treated me like a normal kid, there was no fuss about it. But I used to pray every night that God would make me like other boys."

When he discovered that he had a talent for drawing, the young Richenburg found a way to retreat from his anxieties, at least temporarily. Drawing was "a safe place." And in his maturity as a painter he was able to exorcise those fears, though he wasn't aware of the connection, at least at first.

"I realized that there was a connection many years later. The paintings of the cities are like images of burning coals. The human mind is so complicated. We tell ourselves that we know ourselves, but we don't. What we know is like a halo around it."

Richenburg worked on the black paintings from 1958 to 1964—there are about 60 in all. The series is one of the most important accomplishments of mid-century American art, its richness underlined by the seemingly infinite variations the artist was able to draw from a single technique, and by acknowledging the importance of chance. One of the most imposing canvases is "Changing," in which he imposes a repeated geometric shape—the black circle, in this case—against an allover ground of bright colors. Here, the burning city seems to have been geometrically plotted by some sinister force. The black circles read as black holes. It is as if an alien scientist had taken core samples of the painting to find out what made art tick; it is like a newspaper chart of the phases of a total solar eclipse that always was and always will be. The top and bottom edges of the canvas are riddled with "holes," like the edges of a filmstrip, which suggests that the painting is just one brief section of an epic, a view of a burning city that will never stop burning. It is rare to find a painting so haunted and haunting; it is particularly impressive because it is an abstract painting that carries the kind of narrative force that we associate with Titian or Tintoretto. Richenburg has said that Tobey's allover abstractions caught his eye in this period, and we can see parallels between the two painters in their interest in texture, but Tobey's pictures lack the personal urgency of Richenburg's —"Changing" has a visceral effect on the viewer, while Tobey's paintings evoke detached admiration.

Fall Garden, 1961
oil on canvas, 76 x 56 inches
Collection of the artist.

"Fall Garden," a canvas of just over six feet high and just under five feet wide, can be considered part of the black period though here Richenburg employs, as the title suggests, russets and browns, and the tone is gentler, more elegiac than what pictures such as "Syria" and "Changing" have led us to expect. Still, there is much painterly activity, particularly in the use of inscription, fine, calligraphic scratches in the surface of the painting that seem delicate in contrast with bricklike shapes at the top of the image. There is the suggestion of leaves skating across a street, the warmth of autumn sunlight on bricks. The rhythms are those of nature; despite the intensity of the methods Richenburg employed in making the picture, and its assertive imagery, it has a benign presence.

"Secret Boxes" was made in 1961, the same year as "Fall Garden" and "Changing," and continues the Richenburgian theme of secrecy and revelation, as exemplified by images that lurk behind other images. The picture has an obsessive, allover stencil-like pattern; you could read the design as chain mail or as a pleasant ornamental motif, but either way, you cannot escape it, for the canvas is eight feet high and twelve feet wide. We are sucked into the picture the same way we are sucked into the larger Pollock drip paintings. The magic resides in a careful balance of impulsiveness and repose, in the tension between a superficial, predictable

"[Richenburg] seems to work in an automatist trance, weaving a wonderful complexity, tossing paint into a sea of multicolored surf. Then he pulls across it a curtain of paint as black as Egypt's night"

Lawrence Campbell
Art News, 1959

"His image of a pitch-black place cut through by flickering neon light is persistently urban and nocturnal Pinwheels, discs, rectangles, and squares refer to the mechanical forms of the city. Jagged bursts of light–the light seen through the angular city maze–insist on identification with Times Square. Their primary loudness, for [his] accents are bright orange, red, and yellow, reinforces the city associations. Jarring color and dense blacks pulsate with the cosmopolitan rhythms familiar in Edgar Varese's music."

Dore Ashton
Art and Architecture, 1961

Secret Boxes, 1961
oil on canvas, 96 x 136 inches
Collection of the artist.

design and uneasy waves of color that swell just behind it. Two enigmatic bars of color sit, like a zippered compartment, at the lower center of the image, precisely where a mouth belongs. The queasiness of the image is counteracted by its strange elegance.

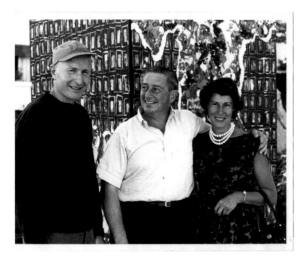

Richenburg, Walter P. Chrysler, Jr. and Chic Richenburg in front of *Broken Continuity*, 1962, Provincetown, MA, 1962.

By 1961, Richenburg was established as an important member of the New York school–"one of the most forceful" artists on the scene, in the critic Irving Sandler's words, and he had attracted the enthusiasm of collectors ranging from James A. Michener to Walter P. Chrysler, who bought 13 canvases for his own collection and for the Provincetown museum that bore his name. Joseph Hirshhorn and Patrick Lannan followed suit; works by Richenburg entered, too, the collections of the Guggenheim, the Whitney, and the Museum of Modern Art.

John Bernard Myers, director of the Tibor de Nagy Gallery, then the premier venue for avant-garde painters in New York, began representing Richenburg in 1959, and shortly thereafter he was included in the important traveling exhibition of "New Talent in the U.S.A. 1960," and had a show at Dwan Gallery in Los Angeles. In 1961 alone, he was included in a trio of major group exhibits, "The Art of Assemblage," at MoMA, "Abstract Expressionists and Imagists," at the Guggenheim, and "Contemporary Paintings–Best of 1960-61 New York Exhibitions," at Yale University Art Gallery, as well as the Whitney Museum's Annual, and in the "Collector's Choice" exhibit at the Baltimore Museum of Art. His third solo show was mounted at Tibor de Nagy, and he had a one-person exhibit at the Santa Barbara Museum, establishing an institutional presence on the West Coast.

The first five years of the 1960s were to be a watershed period in American art, however, and it would not turn out to be a happy time in the careers of many of the New York School painters. By 1964, Pollock had been dead for eight years; de Kooning had moved to the Springs and was considered to have lost his edge. Younger artists were tired of hearing that art was all about existential crisis. The late paintings of Rothko were gloomy; Barnett Newman's "zips" suddenly seemed a bit pretentious; in fact, the whole apparatus of criticism that held aloft the ideal of "action painting" began to be perceived as a balloon full of hot air.

Roy Lichtenstein, Andy Warhol, and James Rosenquist turned the Abstract Expressionist esthetic on its head; ice-cream sodas, soup cans, and Buick Electras supplanted the mythical women of de Kooning and the energy fields of Pollock. Once a new wave of critics and dealers managed to convince a new wave of

collectors and the public that a revolution was under way, Richenburg, and many other important painters of the period, were essentially cast aside, and because Pop Art had so much in common with commercial art, it became popular and marketable in a way that Abstract Expressionism never could have been. "When Pop Art hit, it made me lonely, sad," Richenburg has said. "No one wanted what I had done. I was rejected."

It took several years for Pop Art to take nearly complete control of the New York scene; Richenburg had major shows there and elsewhere through 1964. In 1964 he made a break with the New York scene that could not have been anticipated.

As we have seen, Richenburg is an artist who has always remained open to experimentation, and who understands art as an organic and inner-directed phenomenon; he therefore encouraged his students to try new approaches to art in their own work. Ironically, the artist whose own work was now being seen as old-fashioned by the newest wave of self-appointed tastemakers on the New York scene was considered too much of a loose cannon in an academic setting. The administration at Pratt Institute, where he had taught for 13 years, instructed him to adopt a more conservative approach to the teaching of art, apparently disturbed over reports that Richenburg was allowing his students to make whatever they pleased; one woman produced assemblages of tin foil and rags. He refused, and when the administration failed to grant him the academic freedom he felt he was entitled to, he resigned from the faculty.

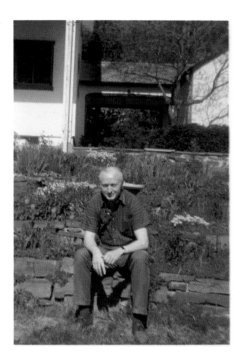

Richenburg at his home in Ithaca, NY, 1966

This represented, of course, a considerable sacrifice; Richenburg had a family to support, and artists who are not independently wealthy cannot usually afford to quit their day jobs. He was quickly hired to teach at Cornell University, and although teaching at Cornell could hardly be interpreted as a step down in prestige, it meant moving to Ithaca, N.Y., abandoning New York and the immediate ties to the art world that were essential to a successful career.

But the move upstate also freed Richenburg. He could work in the kind of relative isolation that often gives birth to new ideas and his paintings of the mid-to-late-1960s show him moving in fresh directions, entering a different phase of creativity.

In fact, some of the playfulness so evident in his earliest work made a return in the works on paper he made in this period, using techniques that enjoyed a vogue in

the days of Surrealism but that had been put aside in the heyday of Abstract Expressionism. Richenburg, of course, was open to any technique and believed in the felicities of accident, as the black paintings made clear.

Collage, the foundation of everything that is modern, allowed Richenburg to transfer his experimental impulse from large stretches of canvas to sheets of paper. Pasting and tearing the paper, transferring images from a wet sheet to a dry one, and using other techniques opened up a new range of expression. In "Window Poke II," one of a series of acrylic collages on paper made in 1966, the effect of a waterfall of color across a four-paned window was created by laying one sheet of painted paper over another and poking through the top sheet. Much as he had done in "Syria" and "Changing," Richenburg created an ambiguous, shifting space. Blue confetti like shapes fall through air that is charged with streaks of red

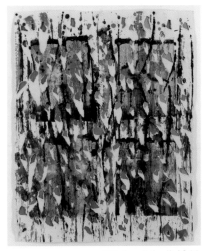

Window Poke II, 1966
acrylic collage on paper, 24 x 19 inches

and yellow. The image, while it is characteristically suggestive, can't be pinned down, and the title, of course, came after the fact. But there is a joyful energy to these pictures that seems as much a result of the artist's delight in discovering new ways to make art as his reflection of the vibrancy of the world outside his window.

"Richenburg Retrospective," The Picker Gallery,
Colgate University, 1970

Richenburg kept changing his art through the 1970s and 1980s. When he momentarily tired of working on paper, he began playing with wire, string, plastic, and tin, and he was never afraid to risk triviality in his search for new means of expressiveness.

"You need to see if you can find a way to make it better by doing it this way, and then that way," he said recently. "You don't change mediums just for sake of change. It's an attempt to intensify the image. One thing leads to another, and it seems endless. I never stopped trying to find a better way. It's like being a madman, really; you just keep going and going. It can raise hell with you, too, trying to find a new way to express yourself, to find the best way to do it. But you have no choice but to keep working that way, even if you feel like you keep failing, and feel like a jerk: Well, it didn't work last time, so I'll just try it this other way. Then I'll try it a different way. You do this for a whole lifetime. But you have no choice. And for that reason I have never understood people like Rothko, who wound up painting the

same picture over and over."

In the 1970s, he made "U Maze" as well as "Locked In," works that simply cannot be categorized except to call them expressive objects that seem, once you have seen them, absolutely inevitable: you wonder why no one made something like them before. They hearken back to the early days of modernism, to Dada, yet they have an authoritative presence; they aren't the deadpan, satirical objects of Duchamp, but speak of the kind of energy we find in Richenburg's paintings. In "U Maze," a series of tightly coiled wires are bent into a "C" shape by tightly laced lengths of red string; there is always the sense that the wire is just about to break the strings that bind it. It has an air of dangerously reined-in energy. The piece measures less than 10 inches in any direction, but seems lethal; it could have come from a bridge designer's bad dream. That the string is red underlines the "dangerous" aspect of the piece.

"Locked In" is another remarkable wire sculpture. In this case, Richenburg made what is essentially a drawing in three-dimensional space using hundreds of wire rings; there is a dynamism here that goes back to Balla and Boccioni, though as always Richenburg is non-programmatic. The piece does not interpret machinery, or symbolize anything in particular; rather, it is an instance of pure motion and form, and because the wire rings are gray, the piece has an understated, formal elegance that counteracts its suggestion of physical energy. Further, the wire rings, with their neat ridges, are like napkin rings, or wedding bands; there is an odd domesticity at work even if the piece can be seen as

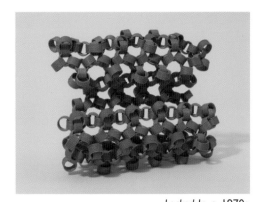

Locked In, c. 1970s
interlocked wire, 11 x 12 1/2 x 6 inches
Collection of the artist.

a striding figure (from the side) or a diagram of molecular structure (from the front). The suggestiveness of the wire structures comes as something of a shock, for Richenburg has trained us to be surprised by his two-dimensional works, and then we discover that his talent translates forcefully from one medium to another.

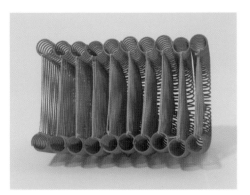

U Maze, c. 1970s
wire with red string, 6 1/2 x 9 x 7 inches
Collection of the artist.

In 1979, Richenburg made an electrifyingly bright blue and red painting in acrylic on paper, "Face to Face," whose astonishingly literal illustration of an argument between two people—or, rather, between two heads, seen in profile —is instantly recognizable in its direct translation of feeling. For one thing, we see two faces with sour expressions; for another, we notice that arrows are shooting out of their mouths and eyes, in direct opposition.

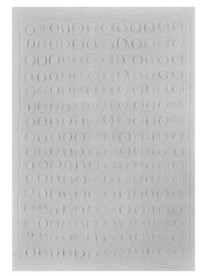

Light Question, 1981
plastic, 34 x 25 inches

On the one hand, this is the least emotionally ambiguous of works of art. But nothing is quite this simple in life, and Richenburg has seen fit, while documenting a condition of rage, to frame the scene in the manner of Seurat, with festive little dabs of pretty colors. The picture's nearly perfect symmetry might emphasize the intensity of this head-to-head confrontation, but it also speaks of order and good taste, and it is in just this kind of paradoxical opposition that his genius resides.

The mystery of "Light Question" (1981), a sheet of transparent plastic with sixteen neatly spaced rows of twelve little ovals, arises out of the slight irregularity from each little cell to the next. They seem like embryos, or samples of some life form deposited by an eyedropper into an assigned spot on a large microscope slide. Then again, they are impressions in plastic. But we respond to their irregularity; like each of us, they have slightly different features and characteristics: What is it, exactly, that allows Richenburg to make a human connection with the most seemingly impersonal of means?

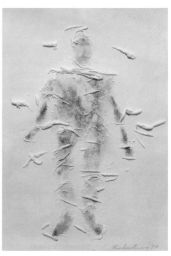

Pagliacci, 1990
frottage, paper, 7 1/8 x 5 inches

Among his other experiments, Richenburg made extensive use of frottage—that is, rubbing. Unlike Max Ernst, who rubbed charcoal or pencil on paper that he pressed on objects, such as floorboards, finding images in those patterns, Richenburg rubbed the paper itself to reveal images, much as he had in the black paintings, and, in a slightly different way, in the "poke" drawings of the 1960s. The "Pagliacci" of 1990, a small portrait of a rainbow-hued man against a white ground, was the result of one such experiment; as Richenburg rubbed away the surface, a figure emerged, a figure who might be singing, his arms held slightly away from

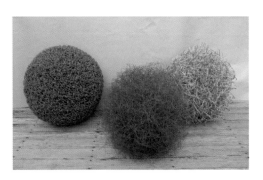

Earth Sphere (Eternal Roll Series), 1971
Galvanized wire, 19 inches in diameter

Air Ball (Eternal Roll Series), 1983
Galvanized wire, 17-18 inches in diameter

Tightly Woven (Eternal Roll Series), 1970-1990
Galvanized wire, 18 inches in diameter

waist level, knees slightly bent. Little curls of paper, the bits that were rubbed away, float around Pagliacci like stylized birds. It is a touching image, the clown seeming to arrive, like an apparition, from pure white light.

Later in the 1970s, Richenburg arrived at a simple and elegant way to capture life,

this time compressing energy in his series of spiral wire works, some of them like tumbleweeds, some like stylized forms of aquatic life. Each says something about infinity, both literally and figuratively. "The spiral," he says, "is like the universe; it never ends."

Marggy and Bob at Guild Hall Museum, East Hampton, 1986
"1 + 1 = 2: Paintings and Sculpture by 40 Artist - Couples"
above: Richenburg, "Pointed U," 1969, paper and steel
Kerr rug sculpture: "Prayer Rug for a Garden," 1986, brick
Photo by Garry Kerr

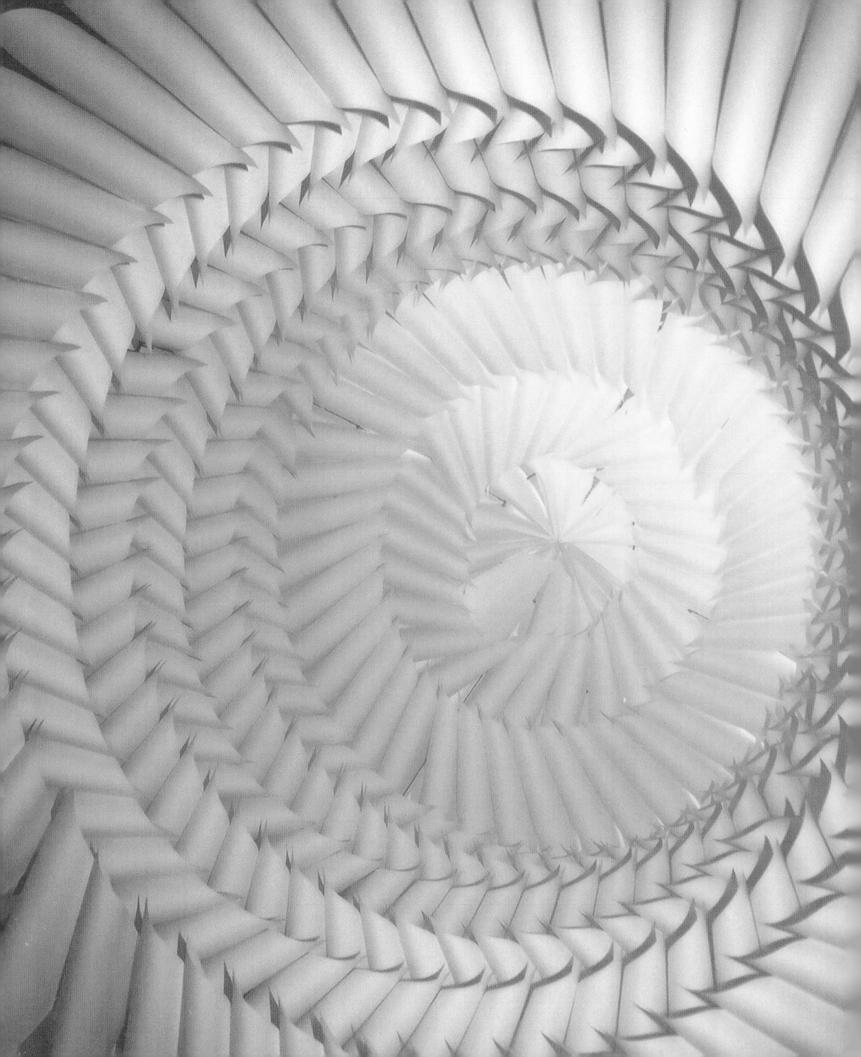

THE RICHARD ZAHN COLLECTION

Study for Ecce Homo, 1946, gouache on paper, 3 3/4 x 7 5/8 inches

Blue Gray, 1947, oil on cardboard, 16 x 18 inches

Study for Pregnant Woman Contemplating Flight, 1947, gouache, 7 5/16 x 8 inches

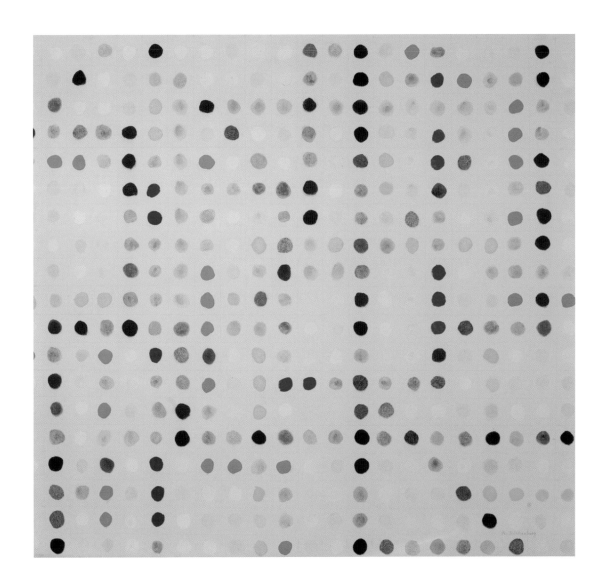

Dotty, 1948, oil on canvas, 28 x 30 inches

From my initial visit to his studio, it was clear that it would take time to get to know his work in all its dazzling variety. His paintings and drawings of the early 1950s held their own with those by more famous contemporaries such as Pollock or de Kooning, whose studio he had visited in 1947. All three men were among the sixty-one artists invited to participate in the celebrated 9th Street Show in 1951. By then Richenburg had already studied with George Grosz, Reginald Marsh, Amadée Ozenfant, and Hans Hofmann. But despite these strong teachers, his art reveals a personal and uncompromising vision.

Gail Levin
Professor of Art History
The City University of New York
© Gail Levin 2002

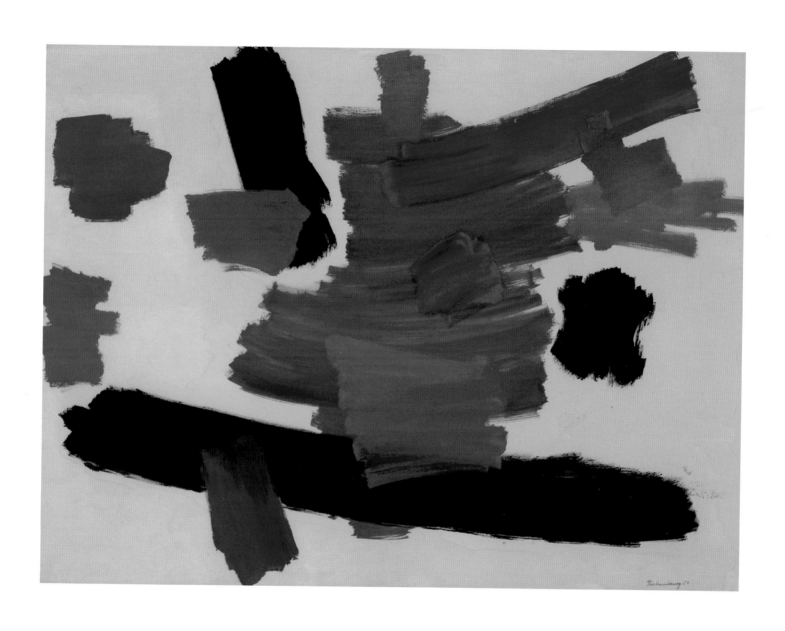

Clouds, 1950, oil on canvas, 44 x 60 inches

The Dancing Figure Series attempted to show the passion and grace of wild dance.
I wanted to express the world of before thinking.

Robert Richenburg

Royal Stomp, 1950, oil on paper, 12 x 17 1/2 inches

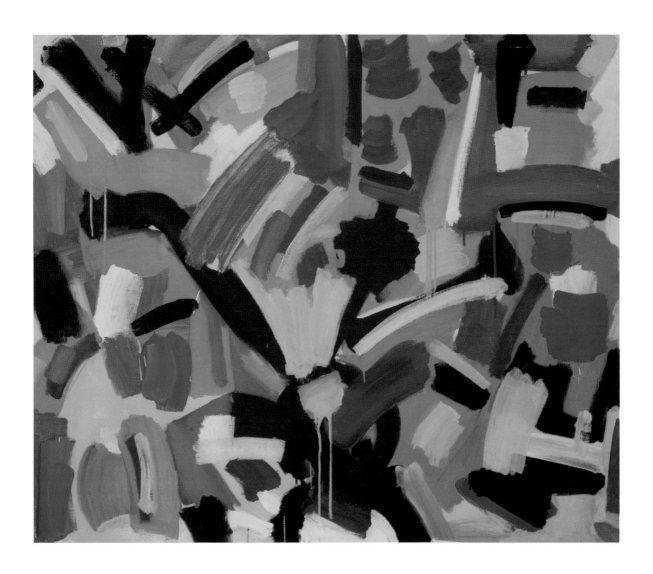

Ecce Homo II, 1950, oil on canas, 42 x 50 inches

The longer and more intensely you look, the more of their secrets Robert Richenburg's paintings will share with you. But they will always hold something in reserve, and that's what makes them endlessly fascinating.

Helen A. Harrison, 2002
Director, Pollock Krasner House,
East Hampton, NY

...From the white paintings the color has vanished like vanished emotion, leaving the shape of the relief to catch the eye with its friction, and then, what survives, is understanding in retrospect.

Fairfield Porter
Art News, March, 1957

Lactescence, 1951, oil and sand on canvas, 50 x 60 inches
Collection of the artist.

Every painting shows Richenburg's struggle to come to terms with Abstract Expressionism, stroke by stroke; it is the obsession of the 84-year-old-artist to this very day. Visible, in particular, is the artist's persistent journey in the old, slow ways of painting–the lone routes of risk and revelation.

Rose C. S. Slivka "Art in America,"
November 2001

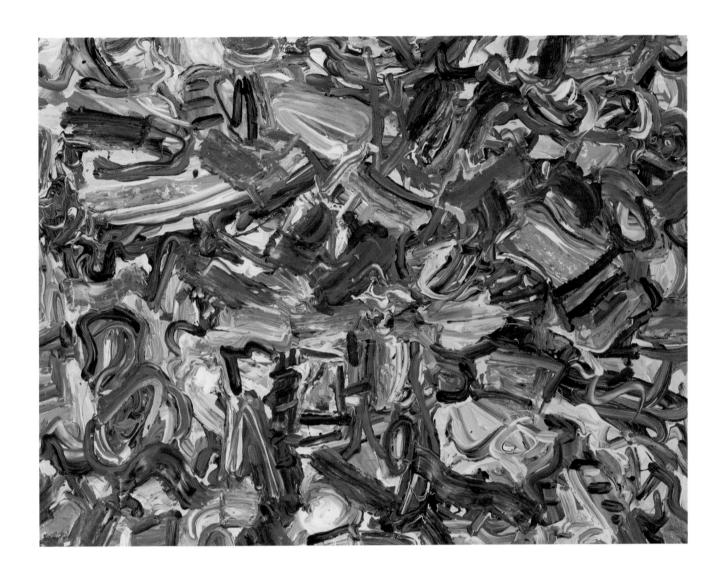

Thunder in the Woods, 1956, oil on canvas, 36 1/4 x 48 inches

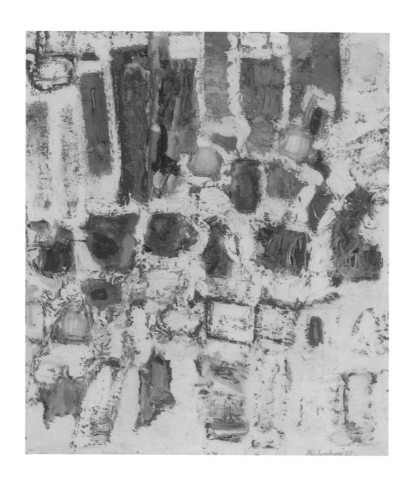

White Abstract (Untitled), 1957, oil on canvas, 28 1/2 x 25 1/2 inches

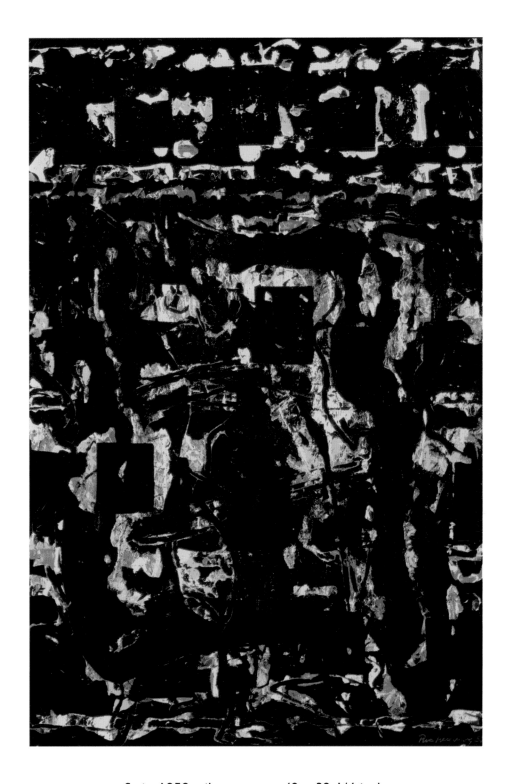

Syria, 1959, oil on canvas, 49 x 32 1/4 inches

(*Hurry* is) part of a system in which I tried to work with the greatest speed possible; to capture an instant of meaning in an instant of time. To become, in a certain sense, one with the painting.

Everything is done quickly, and the rhythms create the meaning. The dimensions of height and width hurry their way in a frenzy. There are no stops, just exhaustion. The picture stops itself.

Robert Richenburg

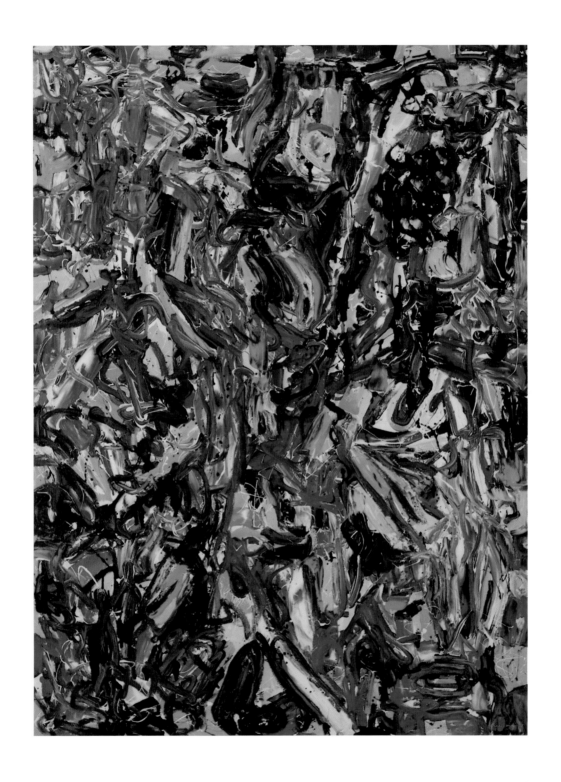

Hurry, 1958, oil on canvas, 76 x 56 inches

Robert Richenburg has a romantic style in which perceptual experience is reconstructed. An image flicks on: a city at night lit up by grids of light, then off: just paint–a matte black skin peeled off to let through a substrata of shiny oil and high-key color. The two levels are as antagonistic as rocks and the sea; however, there is a unity of opposites. White and black separate from the attributes of substance and produce an illusion of light. It is not a painted illusion but a perpetual one that is culled from the naturalistic accidents of paint. Orders such as rows of window shapes and brick patterns make the illusion specific. Buildings are seen–sometimes at night, sometimes blurred by movement, sometimes so close that romantic epigrams and erosion are visible.

Natalie Edgar
Art News, 1961

Concurring with a comment by Stuart Preston in The New York Times, I believe that Robert Richenburg's choice to pay homage to the French romantic poet Paul Valéry in one of the key paintings of his career provides a stunningly apt metaphor for his general artistic beliefs. As Irving Sandler once stated, in the work Richenburg dedicated to Valéry oppositions of matte-black versus color, substance versus light, repression as opposed to sensuality, masculine will versus feminine passion, and nature in contradistinction to the city all seem to be at play. As Preston points out, "Valéry's conviction that the creative act is in itself the subject and theme of artistic creation is certainly paralleled in abstract painting." Following in the footsteps of both Valéry and Goya (another of his personal heroes), over more than six decades the art of Robert Richenburg has continued, as Dore Ashton once remarked, "to disturb the eye, forcing it to look between the crusts for the real painting beneath." This is a major accomplishment indeed.

Ellen Landau
2006

(opposite) *Homage to Valéry*, 1960, oil on canavs, 91 x 81 3/4 inches
Courtesy David Findlay Jr Fine Art, New York.

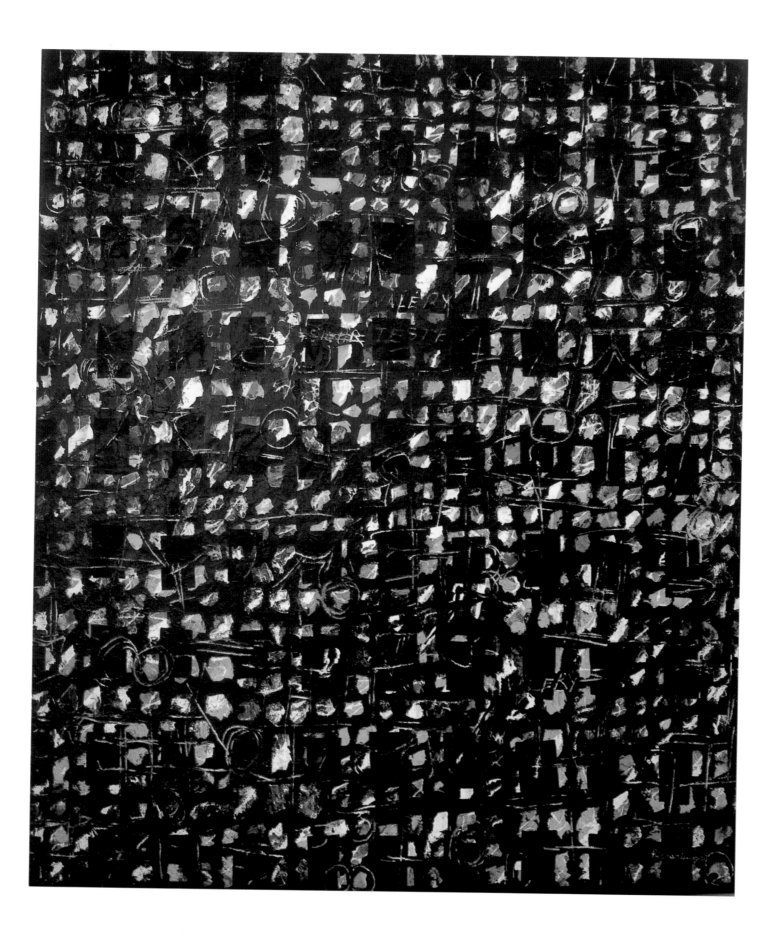

"So much gets in your way. So much can prevent you from being an artist," Richenburg stated. "It is easier to give up and say, well, I have to earn a living You have to find a way around that, because you have to want to make art all the time. You can't push a button and say, 'Now I'm going to be creative.' "

. . . ."An artist must be willing to take risk. In order to make something that is true you have to explore territory you don't really know. You have to take chances." But why is it so difficult to decide to take those chances?

"We are all cowards and heroes at the same time," Mr. Richenburg said, smiling.

Interview with Robert Long,
East Hampton Star, November 2001

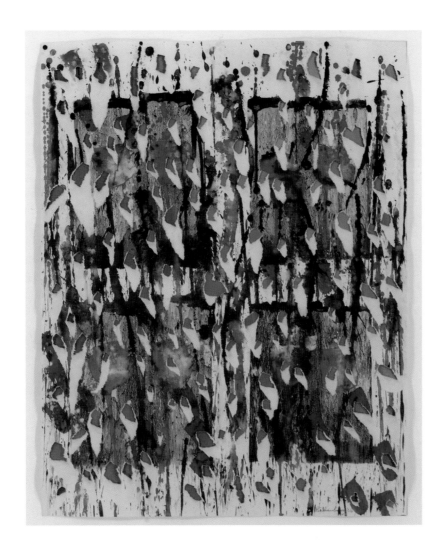

Window Poke II, 1966, acrylic collage on paper, 24 x 19 inches

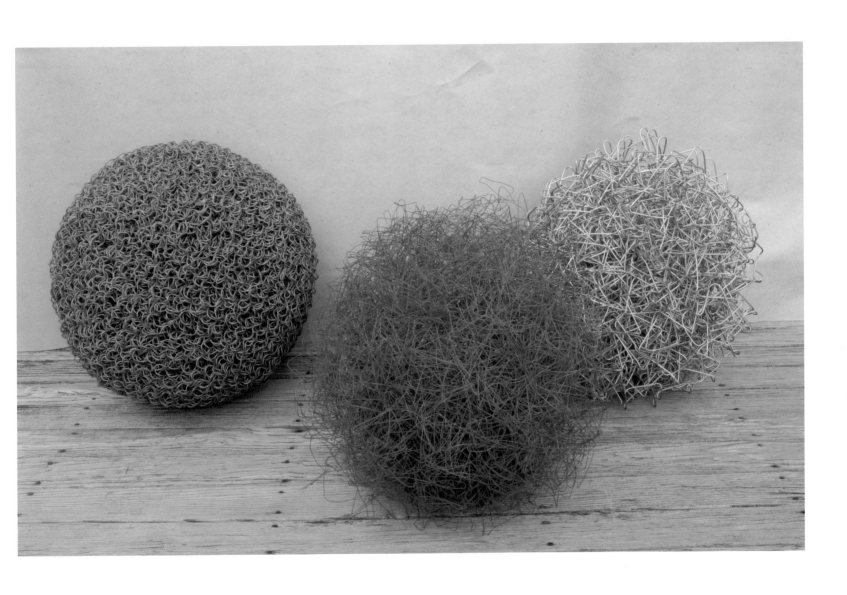

Earth Sphere (Eternal Roll Series), 1971
Galvanized wire, 19 inches in diameter

Air Ball (Eternal Roll Series), 1983
Galvanized wire, 17-18 inches in diameter

Tightly Woven (Eternal Roll Series), 1970-1990
Galvanized wire, 18 inches in diameter

I tried to take my ideas to the extreme
point of meaning: where the meaning
dissolves and turns into a new image;
an image of intensity.

Robert Richenburg
2004

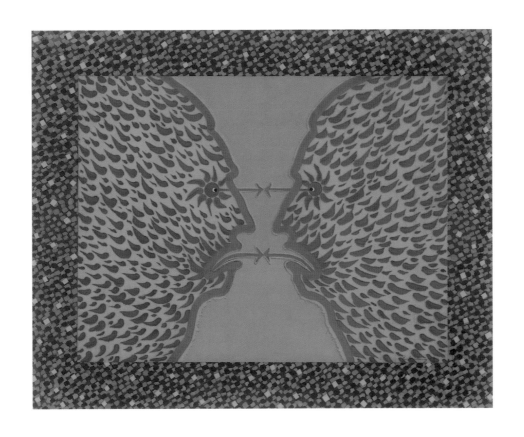

Face to Face, 1979, acrylic on paper, 23 1/2 x 29 1/2 inches

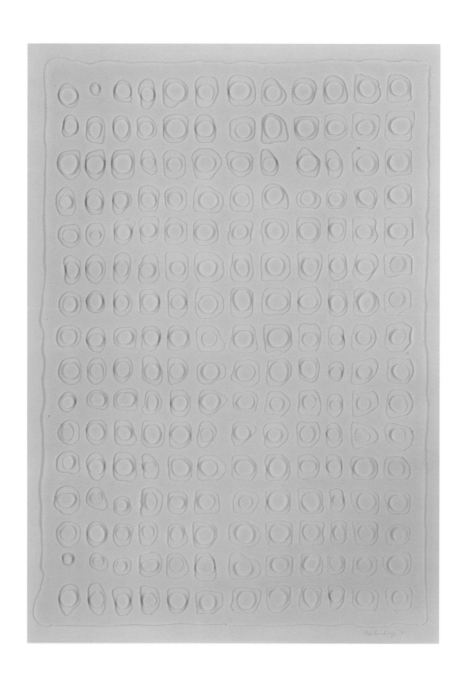

Light Question, 1981, plastic, 34 x 25 inches

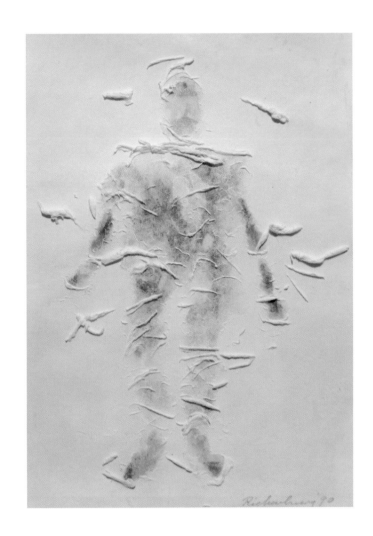

Pagliacci, 1990, frottage, paper, 7 1/8 x 5 inches

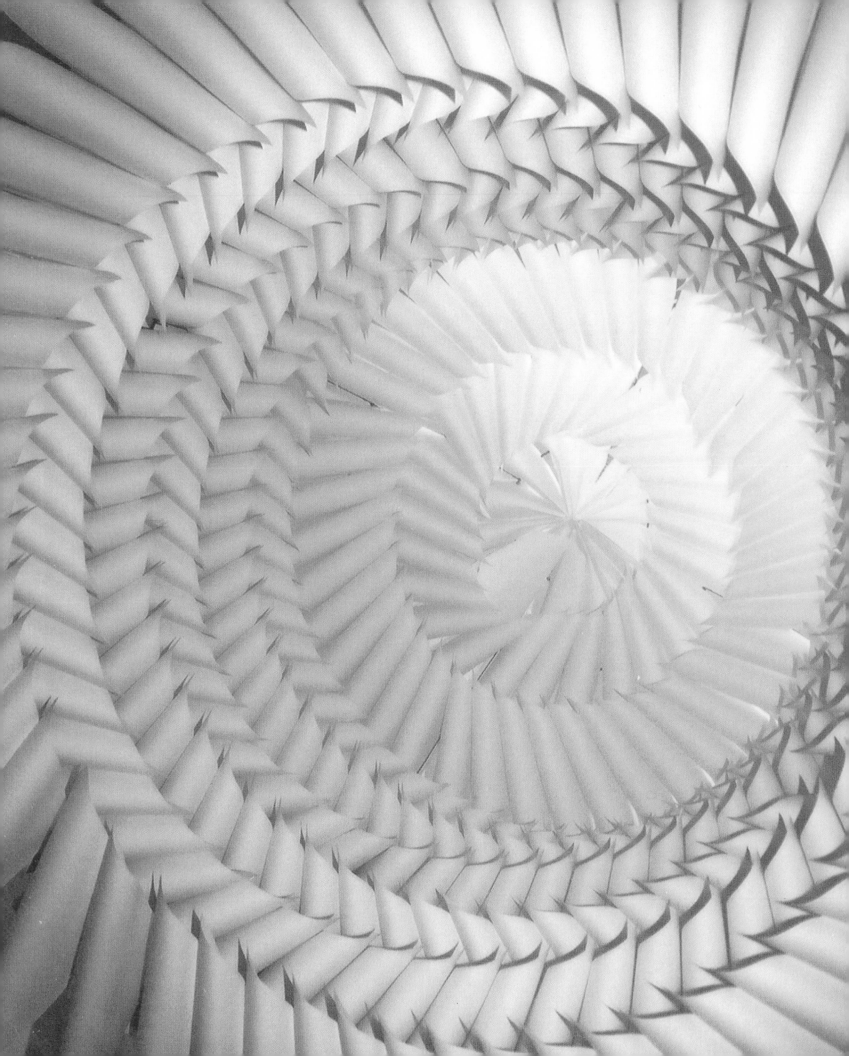

CHRONOLOGY
BIBLIOGRAPHY
EXHIBITION HISTORY
SELECTED MUSEUM COLLECTIONS

ROBERT RICHENBURG
CHRONOLOGY

1917
Born July 14 in Boston, Massachusetts, third of four children to architect Frederick Henry Richenburg and Spray Edna Bartlett Richenburg. Grows up in Roslindale, a suburb of Boston.

Fig. 1

1919
A pot of boiling tomatoes accidentally falls on his head, severely burns him and leaves a bald spot, which affects him physically and

Fig. 2

psychologically for the rest of his life.

1926
Begins drawing at age nine, copying cartoon strips and drawing from nature.

Fig. 3

1931
Enters cartoon drawings and copies of paintings and still life in annual city-wide contest for scholarships to classes at the Boston Museum of Fine Arts. Wins scholarship and draws from casts and tapestries at the museum during afternoons in high school. Wins awards in track and canoeing.

Fig. 4

1933
At the height of the Depression, while still in high school, works with older brother Fred delivering ice, oil and coal to help support the family.

1934
After graduation, at age 16, starts his own ice, oil and coal business with the help of his brother, postponing plans to become an artist. Part owner with his brother of a grocery store, The Village Market, in Roslindale, which fails.

1935
Begins night classes at Boston University, studying history and English while still working full-time.

1936 Attends George Washington University in Washington D.C., studies art history and decides to be an artist.

1940
Drops out of George Washington University to paint; spends four months camping and studying nature in the Sierra Nevada Mountains, and returns to Washington D.C., to study at the Corcoran School of Art. While going to school in Washington works three or four part time jobs: runs a parking lot, is a waiter in a girls' dormitory; distributes and demonstrates Minnesota Mining and Manufacturing

tapes in government offices. Moves to New York to study at the Art Students' League with George Grosz and Reginald Marsh.

1941
Leaves the Art Students' League; spends a year at the Metropolitan Museum of Art copying Rembrandt, Daumier, Cézanne, Renoir, and El Greco; later, on his own, studies Picasso, Mondrian, Miró, Rouault, Surrealism and Dadaism.

1942
Marries Libby Chic Peltyn, and is drafted two weeks later; serves two years in the army in Europe; after being a member of a camouflage outfit, becomes a combat engineer traveling around England and France training troops how to make and dismantle mines, demolitions and booby traps.

1945
Discharged from the army. Teaches art classes at Schrivenham American University in Schrivenham, England. Returns to the United States.

1946
Settles in Provincetown, Massachusetts where he and his wife live for a year.

1947
Moves to New York. Under the G.I. Bill, studies

with Amedée Ozenfant. Meets and becomes friends with Ibram Lassaw. With Lassaw, visits Willem de Kooning's studio, which leaves a lasting impression upon him. Son, Ronald, is born. Begins to teach night art classes for the College of the City of New York, Extension Division, earning $10 for each night of teaching.

1948
Leaves Ozenfant to study in the more open atmosphere of Hans Hofmann's school. Hofmann praises his work at weekly critiques. Work of Picasso, Hans Arp, Miró and Hans Hartung influences him. Begins summering in Provincetown. Later studies with Hofmann in Provincetown as well as New York.

1949
Lassaw invites him to join the Artist's Club shortly after its establishment in 1949. He organizes several of the weekly Friday night panel discussions. Included in Loan Exhibition at the Museum of Non-Objective Painting. (Now known as The Guggenheim Museum, New York, NY).

1950
Receives a stipend for painting materials from Baroness Hilla Rebay,

director of the Museum of Non-Objective Painting, which involves taking work to the Museum for her criticism. Included again in a Loan Exhibition at the Museum of Non-Objective Painting. Included in an exhibit at Provincetown Art Association.

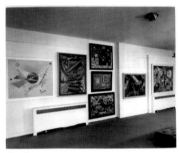
Fig. 5

1951
Begins teaching evenings at the Pratt Institute in

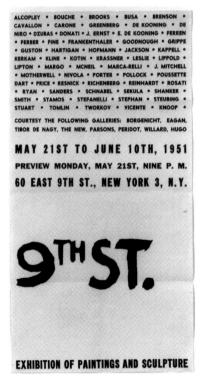
Fig. 6

Brooklyn. Leo Castelli selects "White Cross" for the Ninth Street Show. He exhibits alongside work by the charter members of the Artists' Club, including Kline, de Kooning and Reinhardt.

1952
Included in exhibits at the Provincetown Art Association and the Hendler Gallery. Participates in session on "the Accidental in Art, II" at the Artists' Club in New York.

1953
Shows at the Stable Gallery Annual; solo exhibition at Hendler Gallery, Philadelphia.

1954
Teaches at Cooper Union, New York. Exhibits in second Stable Annual.

1955
Exhibits in third Stable Annual.

1957
Solo exhibitions at the Artists' Gallery, New York, and at Hansa Gallery, New York.

1958
Walter Chrysler buys 13 works; one is the featured work in a special preview at the Chrysler Museum in Provincetown. Work and statement by Richenburg included in "It Is," a new magazine for abstract art.

1959
Solo exhibition of "Black Paintings" at Tibor de Nagy Gallery in New York. John Bernard Myers, director of the gallery, becomes his dealer.

1960
Included in "New Talent in the USA 1960," a traveling exhibition circulated by the American Federation of the Arts. Solo exhibition of "Black Paintings" at Dwan Gallery in Los Angeles. Exhibits in "Four Young Americans" at the Rhode Island School of Design. Second solo exhibition at the Tibor de Nagy Gallery. Teaches at New York University.

1961
Solo exhibition at the Santa Barbara Museum, California. Third solo exhibition at the Tibor de Nagy Gallery. Exhibits in five major group exhibitions: "The Art of Assemblage," Museum of Modern Art, New York; "Abstract Expressionists and Imagists," Solomon R. Guggenheim Museum, New York; "Contemporary Paintings-Best of 1960-1961 New York Exhibitions," Yale University Art Gallery; "Annual," Whitney Museum of American Art, New York; and "Collectors Choice,"

Baltimore Museum of Art.

1962

Fig. 7

Solo exhibition at the Dayton Art Institute, Ohio. Exhibits work in group exhibitions, including "International Selection of Contemporary Painting and Sculpture," Dayton Art Institute; "Twentieth-Century American Paintings," a traveling exhibition of the James A. Michener Foundation Collection.

Fig. 8

1963
Solo exhibtion at the Tibor de Nagy Gallery. Selected

works shown in "Biennial of Contemporary American Painting and Sculpture," Krannert Art Museum, University of Illinois, Urbana; "Biennal of American Painting," Corcoran Museum of Art; "Hans Hofmann and his Students," a Museum of Modern Art traveling exhibition; the Annual sponsored by the Whitney Museum of American Art and "Art Dealer's Review of the Season," Parke-Bernet Gallery in New York.

1964
Resigns position at Pratt due to issues of academic freedom. Accepts a professorship at Cornell University and moves to Ithaca, New York. Solo exhibitions at the Andrew Dickson White Museum at Cornell and Tibor de Nagy Gallery. In the inaugural exhibition of the Larry Aldrich Museum, Ridgefield, CT, and "A Decade of New Talent," an American Federation of Arts traveling exhibition. Buys house at 121 East Remington Road in Ithaca.

1965
Exhibits in "The Emerging Decade," Seattle Art Museum.

1966
Exhibits in "Hilles Collection of Paintings and Sculpture,"

Museum of Fine Arts, Boston.

1967
Moves back to New York to teach at Hunter College where he receives tenure. Exhibits in "Recent Acquisitions in Modern Art," University Art Museum, University of California, Berkeley.

1968
Exhibits in "Painting as Painting," University Art Museum, University of Texas at Austin; "The Square in Painting," organized by the American Federation of Arts and the Whitney Museum Annual.

1970
Teaches at the Aruba Research Center, City University program, Netherlands Antilles. Returns to Ithaca to join faculty of Ithaca College. Retrospective exhibition at the Picker Gallery, Colgate University.

1971
Retrospective exhibition travels to the Ithaca College Museum of Art.

1972
Trip to Northwest Canada.

1975
Travels to Greece, across Europe, and to Ronald's wedding in England.

1976
Solo exhibition at the Upstairs Gallery, Ithaca, New York. Included in "Abstract Expressionist and Imagists, A Retrospective View," at the University of Texas in Austin.

1977
Death of Libby Chic Peltyn.

1979
Summers in East Hampton, Long Island.

1980
Marries artist Margaret Kerr in Ithaca. He inherits three step-children: Blake, Garry, and Meg; a mother and father-in-law and two standard poodles. Moves to 512 Cayuga Heights Road, Ithaca. Rents a house on Three Mile Harbor in East Hampton for the summers of 1980, 1981, and 1982; returns to teach at Ithaca College each winter.

1981
Second solo exhibition at the Upstairs Gallery, Ithaca, N.Y.

Fig. 9

1982
Exhibits in "The Unexpected," Elaine Benson Gallery, Bridgehampton, N Y; and solo exhibition "A Roving Eye," Graduate School of Business, Cornell University.

1983
Retires from Ithaca College; buys a house on Accabonac Harbor, off Springs Fireplace Road in The Springs, East Hampton. Exhibits at Guild Hall Museum, East Hampton; the Bologna/Landi Gallery, East Hampton; and Cornell University Laboratory of Orinthology.

1984
Selected sculptures included in "Outdoor Sculpture 1984: Fifteen Ithaca Artists," Ithaca and "Ordinary and Extraordinary Uses: Objects by Artists," Guild Hall Museum, East Hampton. Granddaughter Alexandra is born to Ron and Kate Richenburg, in England. Moves to East Hampton.

1985
Trip to England to meet Alexandra. Exhibits a self-portrait in "Photography Exhibition," Vered Gallery, East Hampton. Family trip to Montana for Garry's graduation from University of Montana and trip through Glacier Park.

1986
New studio is finished attached to East Hampton house; unpacks life's work; unrolls and restretches large "Black Paintings"; Bonnie L. Grad visits studio and begins eight years planning and research towards Brandeis "Robert Richenburg: Abstract Expressionist" exhibition and catalogue essay. Exhibits in "1+1=2, Paintings and Sculpture by 40 Artist-Couples," Guild Hall Museum and in "Jung and Abstract Expressionism," Hofstra University, Hempstead, N Y. Solo exhibition at the Benton Gallery, Southampton, N Y.

1987
Exhibits at Hood College, Maryland, and in a solo exhibition at the Benton Gallery, Southampton. Designs poster for the annual "Springs Artists Exhibition" at the Ashawagh Hall, in the Springs, East Hampton. First open heart surgery for mitral valve repair.

1988
Exhibits in "This was Pratt: Former Faculty Centennial Exhibition," Pratt Institute. Solo exhibition at the Benton Gallery.

1990
Participates in "Artists Roundtable Discussion of the Fifties" at the Pollock-Krasner House and Study Center, East Hampton.

Fig. 10

1992
Judged "Best in Show" at Guild Hall Museum members' exhibition by Barbara Haskell, curator, Whitney Museum of Art, for a small wood, wire, paper, canvas, and acrylic sculpture. Solo exhibition: "Robert Richenburg: A Fifty Year Survey," at Guild Hall Museum. Trip to England to visit family and the gardens of England and Wales.

Fig. 11

1993
Retrospective at The Rose Art Museum, Brandeis University: "Robert Richenurg: Abstract Expressionist." Grandson Zachary is born to Blake and Kate Kerr.

1994
"Robert Richenburg: Abstract

Expressionist" retrospective travels to Staller Center for the Arts, Stonybrook, NY. The Pollack-Krasner House has a solo exhibition of works on paper from the retrospective. Exhibits at The Sydney Mishkin Gallery, Baruch College, New York, NY; Provincetown Art Association and Museum, and solo exhibition at the Arlene Bujese Gallery in East Hampton.

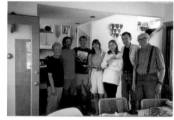
Fig. 12

1997
Exhibits at The Parrish Museum, Southampton, NY. Grandaughter Kaley is born to Blake and Kate Kerr.

Fig. 13

1999
Exhibits at The Parrish Museum.

2000
Exhibits at The Parrish Museum. Second open heart surgery for a new aortic

valve, followed by a stroke five days later: spends from May 16 to July 19 in hospitals.

2001
Solo exhibition at MB Modern Gallery, New York, NY: "Robert Richenburg: Metamorphosis." Exhibits at the Thomas McCormick Gallery, Chicago, IL, the Gary Snyder Gallery, New York, NY: "Abstract Expressionism-Expanding The Canon," and the Parrish Museum.

2002
Solo exhibition at Thomas McCormick Gallery: "Robert Richenburg: Evolution of The Dark Paintings 1950-1960," and family trip to Chicago. Exhibits at David Findlay Jr Fine Art, New York, NY. Gary Snyder Gallery, The Heckscher Museum, Huntington, NY.

Fig. 14

2003
Solo Exhibtion at David Findlay Jr Fine Art: "Robert Richenburg at 85: A Survey." Exhibits at Thomas McCormick Gallery, Guild Hall Museum, Hemphill Gallery, Washington DC. Grandson Finn is born to

Meg Kerr and Carl Paulsen.

Fig. 15

2004
Solo exhibition at David Findlay Jr Fine Art. Exhibits at Thomas McCormick Gallery and the Rockford Museum, Rockford, IL: "Reuniting an Era: Abstract Expressionists of the 1950s."

Fig. 16

2005
Solo exhibtion at David Findlay Jr Fine Art: "Robert Richenburg: Works on Paper from the 1940s." Exhibits at Thomas McCormick Gallery, Arkansas Arts Center, Little Rock, AK, Opalka Gallery, Albany, NY, and Westport Arts Center, Westport, CT.

Fig. 17

2006
"Robert Richenburg: Works on Paper from the 1940s," travels to Thomas McCormick Gallery; exhibits at David Findaly Jr Fine Art.

Granddaughter Alice Claire is born to Meg Kerr and Carl Paulsen.

Fig. 18

CHRONOLOGY PHOTOGRAPHS

Fig. 1
Robert Richenburg's parents: Spray Edna Bartlett Richenburg (1888-1962) and Frederick Henry Richenburg (1886-1960)

Fig. 2
Childhood home of Robert Richenburg, Roslindale, MA, c. 1930

Fig. 3
Drawing by Richenburg, 1929

Fig. 4
Robert Richenburg, age 13, 1931

Fig. 5
Richenburg's work, alongside work by Rolph Scarlett, in the "Loan Exhibition" at the Museum of Non-Objective Painting, 1949

Fig. 6
Poster for "The 9th Street Show" by Franz Kline, 1951

Fig. 7
Richenburg in front of *Night Cascade*, 1961, oil on canvas, 96 x 136 inches, now in the permanent collection of Instituto Valenciano de Arte Moderno, Valencia, Spain

Fig. 8
Richenburg standing by *Broken Continuity*, 1962, Provincetown, 1962

Fig. 9
Wedding of Marggy and Bob at Kerr house, Ithaca, NY, 1980

Fig. 10
Artists' Roundtable on art of the fifties, moderated by Dore Ashton, 1990. Left to right: Ibram Lassaw, Robert Richenburg, Ray Hendler, Sidney Geist, Dore Ashton, Mercedes Matter, Ernestine Lassaw, David Slivka and Herman Cherry

Fig. 11
"Robert Richenburg: A Fifty Year Survey," Guild Hall Museum, 1992. Hanging sculpture foreground is Tar Birds, 1968, tarpaper and aluminum rods, 66 x 36 x 45 inches

Fig. 12
Ron Richenburg, Arlene Bujese, Robert Richenburg, 1994. Paintings left to right: Tangle, 1956, oil on canvas, 60" x 50", Mooncross, 1961, oil on canvas, 57" x 39"

Fig. 13
Left to right: Marggy, Carl Paulsen, Garry Kerr, Meg Kerr (married to Carl), Alexandra Richenburg, Ron Richenburg, Robert Richenburg. Photo by Arlene Bujese, 1998

Fig. 14
Richenburg, David Slivka and Virginia Dwan at the opening of "Robert Richenburg at 85: A Survey," at David Findlay Jr Fine Art, 2003

Fig. 15
Bob meets his new grandson: Bob, Meg Kerr holding Finn Paulsen, Carl Paulsen, 2003

Fig. 16
Richard Zahn, Julie Zahn, Louis Newman and Richenburg with two spiral ball wire sculptures, 2005. Paintings in background, left to right: Strong Defenses, 1960, Challenge, 1960

Fig. 17
Richenburg with Darlene and Tom Furst, Tom McCormick in back holding *The Final Dance*, 1950, at the opening of "Robert Richenburg: Evolution of the Dark Paintings 1950-1960," Thomas McCormick Gallery, 2002

Fig. 18
Blake Kerr, Bob and Louis Newman reviewing plans for the 2006 traveling exhibition

ROBERT RICHENBURG
BIBLIOGRAPHY

WRITINGS ON
ROBERT RICHENBURG
ART PERIODICALS

Dorothy Grafly, "First Philadelphia Solo by Robert Richenburg," *Art in Focus*, Feb.1953, n.p.

John Ferren, "Stable Sate of Mind," *Art News*, vol.54, May 1955, pp. 23, 63.

Fairfield Porter, "Reviews and Previews," *Art News*, vol. 56, no.1, March 1957, p. 9.

Martica Sawin, "Robert Richenburg," *Arts*, vol. 31, no. 7, April 1957, p. 64.

John Ashbery, "Robert Richenburg," *Art News*, vol. 56, no. 9, Jan. 1958, p. 20.

It Is, Autumn 1958, p.43, plate 30, with reproduction and statement by artist.

It Is, Autumn 1959, pp. 28, 44, two reproductions.

Lawrence Campbell, "Robert Richenburg," *Art News*, vol. 58, no. 7, Nov. 1959, pp. 42-43, with reproduction.

John Canady, "New Talent USA: Painting," *Art in America*, vol. 48, no. 1, Spring 1960, p. 24.

John Bernard Myers, "The Impact of Surrealism on New York School," *Evergreen Review*, vol. 4, no. 12, March-April 1960, p. 85.

Natalie Edgar, "Robert Richenburg," *Art News*, vol. 59, no.10, Feb. 1961, p. 13, with reproduction.

Dore Ashton, "Robert Richenburg," *Arts and Architecture*, April 1961, p. 5, with reproduction.

Irving H. Sandler, "New York Letter," *Art International*, vol. v/3, April 1961, p. 39, with reproduction.

Dore Ashton, "Art USA 1962," *The Studio*, vol. 163, no. 827, March 1962, pp.84-95, with full page reproduction.

G.R. Swenson, "Robert Richenburg," *Art News*, vol. 61, no. 1, March 1962, p. 13, with reproduction.

Donald Judd, "Robert Richenburg," *Arts Magazine*, vol. 36, no. 7, April 1962, p. 58.

"International Selection," *The Dayton Art Institute Bulletin*, vol. 21, no. 1, Sept. 1962, unpaged, with reproduction.

James A. Michener, "James A. Michener on Richenburg," *Art Voices*, vol. 1, Nov. 1962, pp. 22-23, photograph of artist in his studio and two reproductions.

Irving H. Sandler, "Robert Richenburg," *Art news*, vol. 62, no. 2, April 1963, p. 15.

Donald Judd, "New York Exhibitions: In the Galleries," *Arts Magazine*, vol. 37, no. 7, April 1963, p. 58.

"Robert Richenburg," *Art International*, vol. VII/4, April 25, 1963, pp. 59-60.

Irving H. Sandler, "Robert Richenburg," *Art news*, vol. 62, no. 2, April 1963, n.p., with reproduction.

Dorothy Seckler, "Artists in America: Victim of the Cultural Bloom?" *Art in America*, vol. 51, Dec. 1963, p. 36, with photograph of artist.

"Fifty-six Painters and Sculptors," *Art in America*, vol. 52, no. 4, August 1964, p. 40, with reproduction.

Lawrence Campbell "Robert Richenburg," *Art news*, vol. 63, no. 8, Dec. 1964, p. 13, with reproduction.

Tom Styron, "Abstract Expressionism Featured in Temporary Exhibition," *Chrysler Museum at Norfolk* (publication), Oct. 1979, n.p.

Donald Judd, "Issues and Commentary," *Art in America*, vol. 72, no.8, Sept. 1984, p. 13.

"Massachusetts: Provincetown Art Association: New York-Provincetown: The 50s Connection," *American Art Review*, Vol. VI, no. 3, June-July 1994, reproduction, p. 96.

"Virginia: Muscarelle Museum of Art: The Conceptual Canvas: Abstract Expressionist Painting," *American Art Reivew*, vol. VI, no. 3, June-July 1994, reproduction p. 124.

Robert Zaller, "When American Art Came of Age: Recovering Robert Richenburg," *El, Greek Arts Magazine*, October-November-December, 1995, p. 40, (English translation p. 12), with photograph of artist and three reproductions.

"Robert Richenburg at MB Modern gallery," *Abstract Art Online*, January 2001 issue.

Rose C. S. Sliva, "Robert Richenburg at MB Modern," *Art in America*, November 2001 p. 149, reproduction p. 150.

Garrett Holg, "Abstract Expressionism: Second to None," Thomas McCormick Gallery, Chicago, *Art News*, December 2001, p. 144.

N.F. Karlins, "Drawing Notebook: 500 Works On Paper 1922-2002," Gary Snyder Fine Art, New York, NY.*Artnet.com/Magazine/Reviews/Karlins*, August 15, 2002.

"What's new?" cover story on recent acquisitions, *The Heckscher Museum of Art Bulletin*, July-August 2002.

Garrett Holg, "Black," Thomas McCormack Gallery, Chicago, *Art news*, January 2005, p. 130, with reproduction.

NEWSPAPER AND POPULAR MAGAZINES

Eugene C. Goossen, "Current Art Scene in New York Reviewed," *Monterey Peninsula Herald*, Nov. 4, 1949, p. 16.

Dorothy Adlow, "Are These the Landscapes of Tomorrow?" *Christian Science Monitor*, vol. 42, Sept. 16, 1950, p. 7.

Gertrude Benson, "In a One Man Show at the Hendler Gallery," *Philadelphia Inquirer*, Feb. 8, 1953, n.p.

"Many Attend Opening of Gallery 256," *Provincetown Advocate*, Sept. 3, 1953, p. 3, group photograph.

"Gallery 256 Sets Two Week Record," *Provincetown Advocate*, Sept. 17, 1953, p. 5.

Dore Ashton, "Robert Richenburg," *The New York Times*, vol. CVI, no. 36, 209, March 14, 1957, p. L39.

"Goings on About Town, Robert Richenburg," *The New Yorker*, vol. 33, March 23, 1957, p. 8.

Richard J. Walton, "Famed Modern Artists in Heights Art Show," *World Telegram and Sun*, Brooklyn Section, June 4, 1958, p. B-2.

Helen Bishop, "Robert Richenburg's 'Pieta' Shown At Chrysler Museum Pre-View," *Provincetown Advocate*, Aug. 21, 1958, p. 4.

"What Is?" *Time*, vol. 74, no. 6, Aug. 10, 1959, p. 62.

Dore Ashton, "Works by Richenburg Shown," *The New York Times*, vol. CIX, no. 37, 168, Oct.29, 1959, p. L44.

"Recently Reviewed," *The New York Times*, vol. CIX, no. 37, 171, section 2, Nov. 1, 1959, p. 21.

"Goings on About Town, Robert Richenburg" *The New Yorker*, Nov. 7, 1959, p. 11.

Arthur Alpert, "People to Blame if They Don't like Modern Art, Says Abstractionist," *World Telegram and Sun*, Brooklyn Section, Aug. 1, 1960, p. B-2.

Henry Seldis, "Large Canvases Are Stunning Decorations," *Los Angeles Times*, Nov. 8, 1960, n.p.

Stuart Preston, "Ends and Means of Abstract Art," *The New York Times*, vol. CX, no. 37, 640, section 2, Feb. 12, 1961, p. 21.

Fairfield Porter, "Robert Richenburg's Paintings," *The Nation*, vol. 192, no. 8, Feb.25, 1961, pp. 175-176.

"Richenburg Exhibit Will Open Tuesday," *Santa Barbara News-Press*, July 30, 1961, p. C-15.

Larry Rottersman, "Richenburg Works Personal, Vital," *Santa Barbara News-Press*, Aug. 4, 1961, n.p.

"N.Y. Painters To Be Discussed in Gallery Talk," *Santa Barbara News-Press*, Aug. 23, 1961, p. A-3.

"Richenburg Show to Close Tonight; Sculpture Stays," *Santa Barbara News-Press*, Aug. 27, 1961, p. C-11.

Stuart Preston, "All Unquiet on the Wide Abstract Expressionist Front," *The New York Times*, vol. CXI, no. 37, 885, section 2, Oct. 15, 1961, p. 17.

Irving H. Sandler, "In the Art Galleries," *New York Post*, vol. 160, no. 292, Oct. 29, 1961, p. 12.

Irving H. Sandler, "In the Art Galleries," *New York Post*, vol. 161, no. 32, Dec. 24, 1961, p. 12.

Emily Genauer, "The Galleries-A Critical Guide," *The New York Herald Tribune*, Feb. 24, 1962, n.p.

Stuart Preston, "In His Paintings at the Tibor de Nagy Gallery ," *The New York Times*, vol. CXI, no. 38, 018, section 2, Feb. 25, 1962, p. 17.

Irving H. Sandler, "In the Art Galleries," *New York Post*, vol. 161, no. 96, March 11, 1962, p. 12.

"Experimental Painting," *Cape Cod Standard-Times*, vol. 26, no. 169, Aug.30, 1962, p. 2, with photograph of the artist with his work.

Irving H. Sandler, "In the Art Galleries," *New York Post*, vol. 162, no. 24, March 10, 1963, p. 14.

"Old Man Crazy About Painting," *Newsweek*, Sept. 16, 1963, pp. 88-90.

Irving H. Sandler, "In the Art Galleries," *New York Post*, vol. 163, no. 40, Jan. 5, 1964, p. 14.

Grace Glueck, "Teacher Backed in Pratt Dispute," *The New York Times*, vol. CXIII, no. 38, 824, section 2, May 11, 1964, p. 38.

Cindy Hughes, "Art Teacher Scores Pratt for 'Standardized' Approach," *World Telegram and Sun*, Brooklyn Section, June 1, 1964, p. B-2.

Staurt Preston, "Human Themes in the Ascendant," *The New York Times*, vol. CXIII, no. 38, 870, July 26, 1964, p. 8.

John Gruen, "Richenburg's Huge Canvases," *The New York Herald Tribune*, Nov, 7, 1964, p. 6.

"Artist's Work to be Shown," *Ithaca Journal*, Nov. 17, 1964, p. 8, with photograph of artist.

Marjorie E. Holt, "Noted Artist Teaches Here," *The Cornell Daily Sun*, Nov. 19, 1964, p. 8, with photograph of the artist.

"Robert Richenburg; Three Other Shows," *Ithaca Journal*, Nov. 19, 1964, p. 2.

Cay Gibian, "Art," *Ithaca Journal*, Nov. 10, 1965, p. 10.

"Hans Hofsmann: 1880-1966," *Newsweek*, vol. 67, Feb. 28, 1966, p. 85.

"Feature Works of Richenburg," *Syracuse Herald-American*, Star Section, Nov. 15, 1970, p. 4.

"Paper Sculptures," *Utica Observer Dispatch*, Nov. 29, 1970, p.10, with two reproductions.

Le Grace Benson, "Richenburg Retrospective," *Ithaca Journal*, Jan.21, 1971, p. 12, with reproduction.

Betsy McLane, "IC Museum Exhibits Richenburg Art Work," *The Ithacan*, Jan. 29, 1971, n.p., with reproduction.

"Prof. to Exhibit Multimedia Art," *Syracuse Post-Standard*, Jan 30, 1976, p. 6.

Kathy Morris, "One particular 'Ithaca Artist', " *Ithaca Journal*, Oct. 16, 1976, p. 3.

"Margaret Kerr and Robert Richenburg: Recent Work," *Ithacan*, Feb. 19, 1981, n.p., with reproduction.

Carol Spence, "Richenburg's Artistic Wealth," *The Ithaca Times*, March 19, 1981, p. 13.

Paul Chambers Hartz, "Ithaca Process: In the Course of Time," Allen Mooney exhibition and Richenburg's The Roving Eye at Cornell, *The Grapevine*, Trmuansburg, NY, February 18-24, 1982, unpaged.

Phyllis Braff, "From the Studio," *East Hampton Star*, April 21, 1983, p. II-6.

Karen Shapiro, "A Garden of Sculptural Delights," *The Ithaca Times*, May 10-16, 1984, p. 13.

Phyllis Braff, "From the Studio," *East Hampton Star*, August 9, 1984, p. II-13, with reproduction.

"Robert Richenburg Spoke at Guild Hall…," *East Hampton Star*, Sept. 20, 1984, p. II-5, with drawing of the artist by Joan Ward.

Rose C. S. Slivka, "From the Studio," *East Hampton Star*, June 26, 1986, p. II-6.

"Robert Richenburg's 'Pointed U'," *East Hampton Star*, Oct. 23, 1986, p. II-9, with reproduction.

Karin Lipson, "Archetypes and Art: The Jung Legacy," *Long Island Newsday, Nassau Suffolk Edition*, Nov. 7, 1986, p. 28.

Phyllis Braff, "Jung as Root of Abstract Expressionism," *The Sunday New York Times*, Long Island Section, vol. CXXXVI, no. 46, 981, section 21, Dec. 7, 1986, p. 40.

"At the Galleries: Benton Show," *East Hampton Star*, April 23, 1987, p. II-7, with reproduction.

"Robert Richenburg's 'Light Filter'," *Southhampton Press*, May 7, 1987, p. B5, with reproduction.

"Springs Art Show Will Feature Those Who Were There at Start," *The Southhampton Press*, July 30, 1987, p. B7.

Phyllis Braff, "New Directions in Prints," *The Sunday New York Times*, Long Island Section, vol. CXXXVI, no. 47, 240, section 2, Aug. 23, 1987, p. 28.

Rose C. S. Slivka, "From the Studio," *East Hampton Star*, Sept. 15, 1988, p. II-9, with reproduction.

Robert Long, "Vered and Benton Exhibits Display a Wide Variety," *Southhampton Press*, Sept. 15, 1988, p. B4.

Rose C. S. Slivka, "From the Studio," *East Hampton Star,* June 1, 1989, p. II-11.

Alastir Gordon, "Figures, Crafts, and Knots," *Long Island Newsday*, Nassau Suffolk Edition, Dec. 8, 1989, p.19.

Rose C.S. Slivka, "From the Studio," *East Hampton Star,* June 6, 1991, p. II-9.

Bridget LeRoy, "Two Solos at Bujese," *The Easthampton Independent*, June 22, 1994, p. 40, with photograph of the artist with Arlene Bujese and Mark Kostabi.

Karin Lipson, "Robert Richenburg Rediscovered: One dedicated fan brings a lost artist back to the public eye," *Long Island Newsday*, July 14, 1994, part 2, cover and p. B4-5, with four photographs.

Jennifer Cross, "Exhibition Gives 2 Views of Post-War America," *The Southamton Press*, March 6, 1997, p. B1.

Marion Wolberg Weiss, " 'Dark Images, Bright Prospects' At the Parrish," *Dan's Papers*, March 7, 1997, p. 35.

Rose C.S. Slivka "From the Studio," *East Hampton Star*, March 13, 1997.

Rose C.S. Slivka "From the Studio: Dramatic Exhibit," *East Hampton Star*, December 10, 1998, p. III-1.

Erica-Lynn Gambino, "A 'Thank-you' Show at Parrish," *The Southampton Press*, December 17, 1998, p. B1.

Marion Wolberg Weiss," 'Gifts For A New Century' At the Parrish," *Dan's Papers*, December 25, 1998, p. 49.

Phyllis Braff, "Recent Acquisitions With Long-Term Potential," *The New York Times*, Long Island Section, December 27, 1998, p. LI 9.

Grace Glueck, "On Long Island, Celebrating Artists Celebrating Nature," *The New York Times*, July 30, 1999, p. E 37.

Rose C.S. Slivka, book review: "New York School Abstract Expressionists: Artist's Choice by Artists," *East Hampton Star*, December 14, 2000, p. III-5, with reproduction.

Sheridan Sansegundo, "At the Galleries: One-Man For Richenburg," *East Hampton Star*, January 4, 2001, p III-3, with reproduction.

Robert Long, "Tempest of Color: Richenburg at MB Modern," *East Hampton Star,* January 18, 2001, p. III-1.

Robert Long, "Parrish Winners: Sloan to Harms," East Hampton Star, December 27, 2001, p. III-1, III-3.

Robert Long, "New Works by Old Masters," *East Hampton Star*, January 17, 2002, p. III-1, with reproduction.

Fred Camper, "In the Shadow of Giants," *Chicago Reader*, May 24, 2002, p. 24, p. 27, with reproduction.

Robert Long, "Robert Richenburg: Six Decades of Making Art," a profile, *East Hampton Star*, December 5, 2002, p. III-1, III-3, with two photographs and one reproduction.

Marion Wolberg Weiss, "Robert Richenburg at 85, At David Findlay Jr Gallery," *Dan's Papers*, February 14, 2003, p. 37.

Marion Wolberg Weiss, "The Ambiguous Toy," at Guild Hall, *Dan's Papers*, November 21, 2003, p. 49.

"Art Inspired by Play," photographs by Durell Godfrey, *East Hampton Star*, Winter Holiday supplement, December 2003, p. 50, with photograph.

Helen A. Harrison, "Few Children Would Yearn for These Toys," *The Sunday New York Times*, Long Island Section, December 21, 2003, p. 10.

Sheridan Sansegundo, "The Art Scene," *East Hampton Star*, December 16, 2004, p. C 2, with reproduction.

Karen Bjornland, "Opalka Show Explores Abstract Expressionism," *Daily Gazette*, Schenectady, NY, February 14, 2005.

BOOKS AND CATALOGUES

Painting and Sculpture Acquisitions Jan. 1, 1959 through Dec. 31, 1959, exhibition catalogue, The Museum of Modern Art Bulletin, vol. XXVII, Nos. 3 and 4, 1960, reproduction on p. 26.

William C. Seitz, *The Art of Assemblage*, Museum of Modern Art, New York, 1961, p. 162.

H.H. Arnason, *American Abstract Expressionists and Imagists*, New York: Guggenheim Museum, 1961, p. 31, reproduction on p. 71.

Whitney Museum of American Art Annual Exhibition 1961: Contemporary American Painting, exhibition catalogue listed no. 108, 1961, unpaged.

Contemporary American Painting and Sculpture 1963, University of Illinois Press, Urbana, Illinois, 1963, reproduction on p. 153.

James A. Michener, *The James A. Michener Foundation Collection*, Foreword by James A Michener, Allentown, Pennsylvania: Allentown Art Museum, 1963, p. vi, with four reproductions.

An Exhibition of the Jean Outland Chrysler Collection, exhibition catalogue, Norfolk Museum of Arts and Sciences, Norfolk, VA, 1963, unpaged, with reproduction.

Whitney Museum of American Art Annual Exhibition 1963: Contemporary American Painting, exhibition catalogue listed no. 112, 1963 unpaged, with reproduction.

The 28th Biennial Exhibition 1963: The Corcoran Gallery of Art, exhibition catalogue, listed no. 114, unpaged.

LSU Union Dedication, Painting and Sculpture Invitational, exhibition catalogue, Louisiana State University, 1964, plate 23.

Old Hundred: Opening Exhibition: Selections From The Larry Aldrich Contemporary Collection, 1951-1964, exhibition catalogue, Ridgefield, CT, 1964, listed no. 54, unpaged.

Six Painters and Sculptors: Cornell University Faculty, exhibition catalogue, The Edward W. Root Art Center, Hamilton College, Clinton, NY, 1965, listed no. 25, 26, 27, 28, 29, unpaged with reproduction.

Sculpture and Painting Today: Selections from the Collection of Susan Morse Hilles, Museum of Fine Arts, Boston, MA, 1966, plate 77.

Sources For Tomorrow: 50 American Paintings 1946-1966 From The James A. Michener Foundation Collection, exhibition catalogue, Introduction by Richard Hirsch, Allentown Art Museum, PA, 1967, circulated by the Smithsonian Institution Traveling Exhibition Service, 1967-1968, p. 7, reproduction, plate no. 40.

Selection 1967: Recent Acquisitions in Modern Art, Introduction by Peter Selz, University of California, Berkeley, 1967, p. 7, reproduction on p. 89.

Painting as Painting, exhibition catalogue, Introduction by Dore Ashton, The Art Museum of the University of Texas, Austin, TX, 1968, reproduction on p. 13.

Whitney Museum of American Art 1968 Annual Exhibition: Contemporary American

Sculpture, exhibition catalogue, listed no. 97, 1968, unpaged.

The Square in Painting, Selected by Richard Anuszkiewicz, exhibition catalogue, essay by Richard Anuszkiewicz, The American Federation of Arts, NY, 1968, listed no. 28.

Robert Richenburg, A Selective Review of Paintings and Sculpture, 1950-1970, The Picker Gallery, Colgate University and Ithaca College Museum of Art, 1970.

Earl A. Powell, III, *Abstract Expressionists and Imagists: A Retrospective View; An Exhibition of Paintings from the Michener Collection,* Austin: University Art Museum 1976, unpaged with reproduction.

James A. Michener, *The James A. Michener Collection: Twentieth Century American Painting,* Austin: University Art Museum, University of Texas, 1997.

Frieden, exhibition catalogue for traveling exhibition of photographs, in Germany, 1983-1984, reproduction p. 42.

Springs: A Celebration, published by Springs Improvement Society, East Hampton, NY, 1984, reproduction p. 10.

Ordinary and Extraordinary Uses: Objects by Artists, exhibition catalogue, essay by

Rose Slivka, Guild Hall Museum, East Hampton, NY, 1984, listed p. 30.

Outdoor Sculpture 1984: Fifteen Ithaca Artists, exhibition catalogue, introduction by Thomas W. Leavitt, listed no. 31, 32, 33, unpaged, with reproduction.

Jung and Abstract Expressionism: The Collective Image Among Individual Voices, exhibition catalogue, text by Terree Grabenhorst-Randall, Hofstra Museum, Hempstead, NY, 1986, p. 10, with reproduction.

C.G. Jung and the Humanities, Karin Barnaby and Pellegrino D'Acierno, eds., Princeton University press, 1990, pp. 198, 206-216.

John Esten, *Hampton Style: Houses, Gardens, Artists,* Little Brown and Company, Boston, 1993, photographs of works p. 183, 185.

Bonnie L. Grad, *Robert Richenburg: Abstract Expressionist,* Rose Art Museum, Brandeis University, Waltham, MA, 1993.

New York-Provincetown: A 50s Connection, 1994 Provincetown Art Association and Museum, exhibition catalogue, essays by Tony Vevers, Phyllis Braff and Cynthia Goodman, reproduction p. 33.

Dark Images, Bright Prospects: The Survival of the Figure After World-War II, exhibition catalogue, The Parrish Museum, Southampton, NY, 1997, listed p. 49.

Lili Bita, *The Scorpion and other Stories,* translated from the Greek by Robert Zaller, Pella Publishing Company, NY, 1998. Cover painting by Richenburg.

New York School Abstract Expressionists: Artists Choice by Artists, edited by Marika Herskovic, New York School Press, New Jersey, 2000, reproductions p. 307 and p. 308.

Starr Ockenga, *Eden on Their minds: American Gardeners With Bold Visions,* Clarkson Potter Publishers, NY, 2001, photograph of rock installation, p. 105.

Robert Richenburg: Metamorphosis, exhibition catalogue, essay by Louis Newman, MB Modern Gallery, New York, NY, 2001, with photograph of the artist.

Abstract Expressionism: Second to None: Six Artists of the New York School, exhibition catalogue, Thomas McCormick Gallery, Chicago, IL, 2001, photograph of the artist p. 14, reproductions pp. 14, 15, 18.

Robert Richenburg: Evolution of the Dark Paintings, 1950-1960, exhibition catalogue, Thomas McCormick Gallery, Chicago, IL, 2002, photograph of the artist, seven reproductions, unpaged.

Robert Richenburg at 85: A Survey, exhibition catalogue, essays by Helen A. Harrison and Gail Levin, David Findlay Jr Fine Art, New York, NY, 2003.

American Abstract Expressionism of the 1950s: An Illustrated Survey, edited by Marika Herskovic, New York School Press, New Jersey, 2003, reproductions pp. 287, 288.

Reuniting an Era: Abstract Expressionists of 1950s, exhibition catalogue, essays by Andrew Zipkes, Thomas McCormick and Gerald Nordland, Rockford Art Museum, Rockford, IL, 2004, reproduction p. 73.

Well Put Together: Abstract Expressionist Collage, exhibition catalogue, Thomas McCormick Gallery, Chicago IL, 2004, unpaged, two reproductions.

Robert Richenburg, exhibition catalogue, essay by Ellen G. Landau, David Findlay Jr Fine Art, New York, NY, 2004.

John Esten, *Hamptons Gardens: a 350 year Legacy*, Rizzoli, NY, 2004, photograph of rock installation, p. 127.

New York School: Another View, exhibition catalogue, Opalka Gallery, The Sage Colleges, Albany, NY, 2005, essays by Jim Richard Wilson, Terence Diggory, Esther Tornai Thyssen and Ann Eden Gibson, reproduction p. 58.

Black, exhibition catalogue, Thomas McCormick Gallery, Chicago, IL, 2005, essay by Robert Long, unpaged, three reproductions.

Robert Richenburg: Works on Paper From the 1940s, exhibition catalogue, essay by Robert Long, David Findlay Jr Fine Art, New York, NY, 2005, Thomas McCormick Gallery, Chicago, IL, 2006.

PANELS

"Directions in Modern Art," Provincetown Art Association, Provincetown, MA, July 26, 1951, Adolph Gottlieb, moderator; other participants: Karl Knaths, Ibram Lassaw and Boris Margo.

"Teaching and the Artist-A Contemporary Problem," The Artists' Club, 39 Eighth Street, New York, Oct. 26, 1951. John Ferren, moderator; other participants: Harry Holtzman, Robert Iglehardt and Robert J. Wolff.

"The Accident in Art, II," The Artists' Club, 20 East 14th Street, New York, March 8, 1957. Harry Holtzman, moderator; other participants: Calvin Albert, Michael Goldberg and Burt Hasen.

"The Universities and the Arts," Cornell University, Ithaca, NY, 1965. Other participants Roderick Robertson and Thomas A. Sokol. Part of Cornell University's Centennial Year Class Reunion Programs.

"Provincetown: Memories of Cape Light," Guild Hall Museum, East Hampton, NY, July 23, 1986. B.H. Friedman, moderator; other participants: Howard Kanovitz, Marcia Marcus and Joanne Schneider.

"The Influence of Jungian Theory on Art," Hofstra University, Hempstead, NY, Nov. 21, 1986. In conjunction with the exhibition "Jung and Abstract Expressionism: The Collected Image Among Individual Voices." Teree Grabenhorst-Randall, moderator; other participants: Mark Hasselriis and Ibram Lassaw.

"Artists Roundtable Discussion of the Fifties," Pollock-Krasner House and Study Center, East Hampton, NY, Aug 30, 1990. Dore

Ashton, moderator; other participants: Herman Cherry, Sydney Geist, Ray Hendler, Ernestine Lassaw, Ibram Lassaw, Mercedes Matter and David Slivka.

"Robert Richenburg: Abstract Expressionist," Rose Art Museum, Brandeis University, Waltham, MA October 3, 1993. In conjunction with his retrospective. Other participants: Carl Belz, director of Rose Art Museum; Bonnie L. Grad, guest curator; Helen Harrison and Ibram Lassaw.

"Robert Richenburg: Abstract Expressionist," Pollock-Krasner House and Study Center, June 26, 1994. Robert Richenburg in conversation with Bonnie L. Grad, Curator of "Robert Richenburg: Abstract Expressionist."

VIDEO AND AUDIOTAPES

"Robert Richenburg," Archives of American Art, Smithsonian Institution, Oral History Collection, 1965: Interviewed by Dorothy Seckler. (audiotape)

"Robert Richenburg: A Studio Visit," Focus on Art, Produced by the Tompkins County Public Library in cooperation with area video archives, Ithaca, NY 1982: Interviewed by Johnnie Parrish. (videotape)

"Robert Richenburg, Artist" *Art Beat*, vol. 1, #2, taped at LTV studio, East Hampton, NY 1986: Joe Stefanelli, Host. (videotape)

"Artists' Roundtable Discussion of the Fifties," Pollock-Krasner House and Study Center, East Hampton, NY, Aug. 30, 1990. Dore Ashton, Moderator; other participants: Herman Cherry, Sydney Geist, Ray Hendler, Ernestine Lassaw, Ibram Lassaw, Mercedes Matter and David Slivka. (videotape)

"American Abstract Expressionists: Robert Richenburg, Artists of the 9th Street Show," edited by Marika Herskovic, Ph.D. and Brett Blear; produced and directed by Thomas Herskovic, 1992. (videotape)

"An Afternoon with New York School Artists, November 8, 1992," participating artists: Ann Arnold, Edward Dugmore, Eadle Dugmore, Harlan Jackson, Ibram Lassaw, Conrad Marca-Relli, Ruth Nivola, Lillian Orlowsky, Charlotte Park, Robert Richenburg, Leatrice Rose, David Slivka and Joe Stefanelli; participating art historians: Yvonne Hagan-Stubing, Arthur Jones, Sandra Kraskin and Ann Williams. Edited by Marika Herskovic and Brett Blear. Produced and directed by Thomas Herskovic, 1992. (videotape)

"Hans Hofmann, Reflections by Former Students," seven minute video, including original footage of Hofmann, produced by Madeline Amgott and Muse Television with the assistance of Tina Dickey. Shown at the Metropolitan Museum in connection with the 1999 exhibition "Hans Hofmann in the Metropolitan Museum of Art." (videotape)

SELECTED EXHIBITIONS

2006 Thomas McCormick Gallery, *Robert Richenburg: Works on Paper from the 1940s*, Chicago, IL (solo exhibition).
David Findlay Jr Fine Art, *Twelve New York Painters*, New York, NY
David Findlay Jr Fine Art, *Nine Artists From the Ninth Street Show*, New York, NY

2005 Arkansas Arts Center, 2005 *Collectors Show and Sale*, Little Rock, AK
Opalka Gallery, The Sage Colleges, New York School: *Another View*, Albany, NY
Westport Arts Center, *About Paint*, Westport, CT
Thomas McCormick Gallery, *Black*, Chicago, IL
David Findlay Jr Fine Art, *American Abstractionists*, New York, NY
David Findlay Jr Fine Art, *Robert Richenburg: Works on Paper from the 1940s*, New York, NY (solo exhibition)

2004 David Findlay Jr Fine Art, *Robert Richenburg*, New York, NY (solo exhibition)
Rockford Art Museum, *Reuniting an Era: Abstract Expressionists of the 1950s*, Rockford, IL
David Findlay Jr., *Face to Face*, New York, NY
Thomas McCormick Gallery, *Well Put Together: Abstract Expressionist Collage*, Chicago, IL

2003 David Findlay Jr Fine Art, *Robert Richenburg at 85: A Survey*, New York, NY (solo exhibition)
Hemphill Gallery, *Abstraction 1949-1959*, Washington, DC
Guild Hall Museum, *The Ambiguous Toy*, East Hampton, NY
Thomas McCormick Gallery, *The New York School and Beyond*, Chicago, IL

2002 David Findlay Jr Fine Art, *Kindred Spirits*, New York, NY
David Findlay Jr Fine Art, *Continuums: Matsumi Kanemitsu, Fred Mitchell & Robert Richenburg*, New York, NY
Thomas McCormick Gallery, *Robert Richenburg: Evolution of the Dark Paintings 1950-1960*, Chicago, IL (solo exhibition)
The Heckscher Museum of Art, *What's New: Recent Additions to the Museum's Permanent Collection*, Huntington, NY
Gary Snyder, *500 Works on Paper*, New York, NY

2001 Gary Snyder, *Abstract Expressionism- Expanding the Canon*, New York, NY
Thomas McCormick Gallery, *Second to None*, Chicago, IL
MB Modern, *Robert Richenburg - Metamorphosis*, New York, NY (solo exhibition)
Parrish Art Museum, *Conversations Around a Collection: Acquisitions 1999-2001*, Southampton, NY

2000 Parrish Art Museum, *The Nature of Seeing: Works from the Collection*, Southampton, NY

1999 Parrish Art Museum, *As American As... 100 Works from the Collection*, Southampton, NY
Parrish Art Museum, *Gifts for a New Century*, Southampton, NY.

1997 Parrish Art Museum, *Dark Images, Bright Prospects: The Survival of the Figure after World War II*, Southampton, NY

1994 Pollock-Krasner House, *Works on Paper*, East Hampton, NY (solo exhibition)

Staller Center for the Arts, State University of NY, *Robert Richenburg: Abstract Expressionist*, Stonybrook, NY (solo exhibition)

Sidney Mishkin Gallery, Baruch College, *Reclaiming Artists of the New York School: Toward a More Inclusive View of the 1950s*, New York, NY

Provincetown Art Association and Museum, *New York-Provincetown: A 50's Connection*, Provincetown, MA

Arlene Bujese Gallery, *Robert Richenburg*, East Hampton, NY (solo exhibition)

The Muscarelle Museum of Art, College of William and Mary, *The Conceptual Canvas: Abstract Expressionist Paintings from the Muscarelle Museum of Art's Jean Outland Chrysler Collection*, Williamsburg, VA

1993 Rose Art Museum, Brandeis University, Robert *Richenburg: Abstract Expressionist*, Waltham, MA (solo exhibition)

1992 Guild Hall Museum, *Robert Richenburg: A Fifty-Year Survey*, East Hampton, NY (solo exhibition)

1988 Benton Gallery, Southampton, NY (solo exhibition).

Pratt Manhattan Gallery, *This was Pratt: Former Faculty Centennial Exhibition*, NY, and subsequently at the Schafler Gallery, Pratt Institute, Brooklyn, NY

1987 Benton Gallery, Southampton, NY (solo exhibition).

The Hodson Gallery, Hood College, *10 From New York*, Frederick, MD

1986 Emily Lowe Gallery, Hofstra University, *Jung and Abstract Expressionism*, Hempstead, NY

Benton Gallery, Southampton, NY (solo exhibition).

Guild Hall Museum, *1+1=2, Paintings and Sculpture by 40 Artist-Couples*, East Hampton, NY.

1985 Vered Art Gallery, *Photography Exhibition*, East Hampton, NY

1984 Guild Hall Museum, *Ordinary and Extraordinary Uses: Objects by Artists*, East Hampton, NY.

Bologna Landi Gallery, East Hampton, NY

Outdoor Sculpture *1984: Fifteen Ithaca Artists*, Ithaca, NY

1983 Kunstverein Wolfsburg, Galerie fur Photographie, Braunschweig, Museum fur Moderne Kunst, Goslar, Frieden (an exhibition of photographs), and subsequent tour in Germany, 1983-1984.

Guild Hall Museum, *Arrivals*, East Hampton, NY

Cornell University Laboratory of Ornithology, *An Exhibit of Bird Art*, Ithaca, NY

Bologna Landi Gallery, East Hampton, NY

1982 Cornell University, Graduate School of Business Gallery, *A Roving Eye*, Ithaca, NY (solo exhibition).

Elaine Benson Gallery, *The Unexpected*, Bridgehampton, NY.

1981 The Upstairs Gallery, Ithaca, NY (solo exhibition).
1980 Cornell University, Graduate School of Business Gallery, *Ithaca Artists*,
 Ithaca, NY
1976 University of Texas, *Abstract Expressionists and Imagists, Retrospective
 View*, Austin, TX

 The Upstairs Gallery, Ithaca, NY (solo exhibition)
1971 Ithaca College Museum of Art, *Robert Richenburg: A Selective Review of
 Paintings and Sculpture, 1950-1970*, Ithaca, NY (solo exhibition)
1970 The Picker Gallery, Colgate University, *Robert Richenburg: A Selective
 Review of Painting and Sculpture, 1950-1970*, Hamilton, NY (solo
 exhibition)

 Tibor de Nagy Gallery, *The 1950s Revisited: Twentieth Anniversary
 Exhibition of Gallery Alumni*, New York, NY
1968 American Federation of Arts, *The Square in Painting*, traveling exhibition,
 1968-1969

 University Art Museum, University of Texas, *Painting as Painting*,
 Austin, TX

 Whitney Museum of American Art, *Whitney Museum of American
 Art Annuals and Biennials*, New York, NY (also 63, 61)
1967 *Sources for Tomorrow: 50 American Paintings 1946-1966* From
 The James A. Michener Foundation Collection Allentown Art
 Museum, circulated by the Smithsonian Institution Traveling
 Exhibition Service (through 68)

 University Art Museum, *Recent Acquisitions in Modern Art*, Berkeley, CA
1966 Museum of Fine Arts, *Hilles Collection of Paintings and Sculpture*, Boston,
 MA

 The Larry Aldrich Museum, *Selections From The Museum Collection
 1951-1965*, Ridgefield, CT
1965 Seattle Art Museum, *The Emerging Decade*, Seattle, WA

 The Edward W. Root Art Center, *Six Painters and Sculptors: Cornell
 University Faculty*, Hamilton College, Clinton, NY

 Bloomsberg State College, *Exhibition of Paintings On Loan From The
 Collection of the Living Arts Foundation of New York City*, Bloomsburg, PA
1964 Tibor de Nagy Gallery, New York, NY (solo exhibitions) (also 63, 61, 60,
 59)

 Andrew Dickson White Museum, Cornell University, Ithaca, NY (solo
 exhibition)

 American Federation of Arts Gallery, *A Decade of New Talent*, New York,
 NY and subsequent tour

 Larry Aldrich Museum, *Inaugural Exhibition: The Larry Aldrich
 Contemporary Collection, 1951-1964*, Ridgefield, CT
1963 MOMA, *Hans Hofmann and His Students*, New York, NY, traveling
 exhibition

Corcoran Gallery of Art, *Biennial of American Painting*, Washington, DC

Krannert Art Museum, University of Illinois, *Biennial of Contemporary American Painting and Sculpture*, Urbana, IL.

Norfolk Museum of Arts and Sciences, *An Exhibition of the Jean Outland Chrysler Collection*, Norfolk, VA

Parke Bernet Gallery, *Art Dealers Review of the Season*, New York, NY

Allentown Art Museum, The James A. Michener Foundation Collection, Allentown, PA

1962 Rockhill Nelson Gallery, Kansas City, MO, *Twentieth-Century American Paintings (James Michener Collection)*, subsequently at Allentown Art Museum, Pennsylvania State University, and Arkansas Art Center, Little Rock, AR. Through 1963

Dayton Art Institute, *International Selection of Contemporary Painting and Sculpture*, Dayton, OH

Dayton Art Institute, Dayton, OH (solo exhibition)

1961 Baltimore Museum of Art, *Collector's Choice*, Baltimore, MD

Yale University Art Gallery, *Contemporary Paintings-Best of 1960-61, New York Exhibitions*, New Haven, CT

Santa Barbara Museum, Santa Barbara, CA (solo exhibition)

Solomon R. Guggenheim Museum, *Abstract Expressionists and Imagists*, New York, NY

MOMA, *The Art of Assemblage*, New York, NY

1960 Rhode Island School of Design, *Four Young Americans*, Providence, RI

Dwan Gallery, *Black Paintings*, Los Angeles, CA (solo exhibition);

New Talent in the USA, a traveling exhibition, Circulated by American Federation of the Arts

Dwan Gallery, *15 of NY*, Los Angeles, CA

1958 Chrysler Art Museum, Provincetown, MA (solo exhibition).

M. Knoedler & Co., *A to Z in American Arts*, benefit for Provincetown Arts Festival, New York, NY

Chrysler Art Museum, *Provincetown Past and Present*, Provincetown, MA

1957 Artists' Gallery, New York, NY (solo exhibition)

Hansa Gallery, New York, NY (solo exhibition)

1955 Stable Gallery, Annual Exhibition of Painting and Sculpture, New York, NY (also 54, 53)

1953 The New School for Social Research, *Provincetown-New York Artists*, New York, NY

Hendler Gallery, Philadelphia, PA (also 52) (solo exhibition in 1953)

1952 Provincetown Art Association, Provincetown, MA (also , 51, 50)

1951 9th Street Gallery, *The 9th Street Show*, New York, NY

1950 Studio 35: 35 East 8th Street, *Fourteen Under Thirty Six,* New York, NY

Museum of Non-Objective Painting (now the Guggenheim Museum), New York, NY (also 49)

SELECTED MUSEUM COLLECTIONS

Chrysler Museum of Art, Norfolk, VA
College of William and Mary, Williamsburg, VA
Guild Hall Museum, East Hampton, NY
Heckscher Museum of Art, Huntington, NY
Hirshhorn Museum, Washington, DC
Hofstra University Museum, Hempstead, NY
Instituto Valenciano de Arte Moderno, Valencia, Spain
Ithaca College Museum, Ithaca, NY
Johnson Museum of Art, Cornell University, Ithaca, NY
Museum of Modern Art, New York, NY
Parrish Museum of Art, Southampton, NY
Pasadena Museum of Fine Art, Pasadena, CA
Philadelphia Museum of Art, Philadelphia, PA
Rose Art Museum, Brandeis University, Waltham, MA
University Art Museum, UC Berkeley, CA
University of Texas Art Museum, Austin, TX
Whitney Museum of American Art, New York, NY
Zimmerli Art Museum, Rutgers University, New Brunswick, NJ

THE MUSEUM OF NON-OBJECTIVE PAINTING

THE SOLOMON R. GUGGENHEIM FOUNDATION

Cable Address: Noobmuseum, N. Y. - 1071 Fifth Ave. - New York 28, N. Y.

January 3rd, 1950

Mr. Robert Richenburg
68 Cumberland Walk Apt. 10 C
Brooklyn 1, N. Y.

Dear Mr. Richenburg:

We take pleasure in inviting you to partici-
pate in a group showing of non-objective paint-
ings, which will open at the Museum, February
14th, 1950.

Please note that it is necessary that you send
your material framed, ready for hanging; and
that full information - title, medium, size,
date, valuation, etc. - should be legibly
written on the back of it, as well as being
given in a separate letter, with name of owner
and insurance value, sent ahead of sending
painting.

Kindly let us know whether you plan to par-
ticipate in this show, and if so when we can
expect delivery of your material. Please
have each piece clearly marked with your name
and address. Paintings should be at the
Museum no later than February 1st, 1950.

Enclosed is a self-addressed envelope for
your convenience.

Sincerely yours,

Hilla Rebay

Hilla Rebay

An Eye for Innovation:
Richard Zahn & Robert Richenburg

When Richard Zahn first saw the paintings of Robert Richenburg at an exhibit in New York, he was attracted to the risks Richenburg took, as well as the range of his expressiveness. Zahn had been collecting Chinese art as well as regional American art–Grandma Moses and work by Kansas artists in particular–since the time when he was just out of college.

According to Zahn, "There was a woman who went to the church I went to as a child who had been a Chinese missionary, and we would go across the street to visit her, and I became exposed to Chinese culture that way."

When he was newly out of college and recently married, Zahn moved to Kansas City, which has one of the finest collections of Chinese art in the country. William Rockhill Nelson, founder of the Kansas City Star, left money to found the Nelson-Atkins Museum with the proviso that any artists collected must have been deceased for at least 50 years. One solution was to buy Chinese art, which is exactly what a New York art consultant did for the museum in the 1930s.

Zahn's knowledge of Chinese art, combined with a passion for Midwestern regionalism, gave him a deep but selective appreciation for painting. According to Zahn, "I knew about Pollock because of his connection with Thomas Hart Benton. When I first moved to Kansas City, I lived about four blocks away from Benton. He worked every day in a converted garage behind a carriage house. He wasn't treated like an icon. He was 73 or 74, and worked every day. He was an inspiration."

Many years later, Zahn was on East 57th Street to purchase Greek ceramics from an antiquarian. He happened to walk across the hall to David Findlay Jr Fine Art, and was intrigued to learn that Mr. Findlay had been born in Kansas. Gallery director Louis Newman suggested he look at some Richenburgs. Zahn says, "I immediately connected with the work. When I talked to Bob, I found him both engaging and intellectually challenging–both qualities that I admire in his work. I

Robert Richenburg with Richard Zahn in the artist's East Hampton studio, with two wire pieces from the *Eternal Roll Series*.
Photograph by Margaret Kerr, 2005

also found this historically important and pioneering artist to be approachable."

Zahn immediately became fascinated with Richenburg's role in a defining period in American culture, and was particularly taken with the black paintings of the late 1950s. "This was back in 1958," Zahn said, referring to "Hurry" and "Syria," two Richenburg paintings now in his collection. "Think of it. In 1959 and 1960, the Strategic Air Command was in place in parts of Kansas. I remember going downtown with my dad and other veterans and standing on the roof of the two-story fire station to look for Russian planes. The post office gave out free pamphlets on how to build fallout shelters. And while we are all worried about the Soviet threat, here were these artists doing these amazing things–things that were so much more alive! In the historical context, it is great to see what Richenburg was painting, in 'Syria,' for example. It is unique. He said that he went to a dark place when he made that painting."

"Bob said that art is where he felt safe. He was struggling at the time financially, trying to paint and teach. But there are these extraordinary bursts of energy in the form of these paintings. "

"Bob is accessible and esoteric at once," Zahn says, but his admiration for Richenburg extends beyond the artist's aesthetic accomplishments. Zahn perceives the body of work as the exemplary record of a struggle–one that could serve as a model for younger artists.

"Bob Richenburg's work is something you could create an entire course around–in terms of his innovation, in terms of exploration, and leadership. Bob was never satisfied, and always looked to do something better. When he felt he had achieved his ends, Bob went on to another medium, another way of working. There are lessons there about focus, about consistency, about sticking with your own principles. If, for example, it was politically correct to follow the Cubists, or to be an 'action painter' at a particular time, or to do whatever the critics said artists should be doing, Richenburg had already moved on."

Robert Long

Photo of the artist by Regina Cherry, 2005

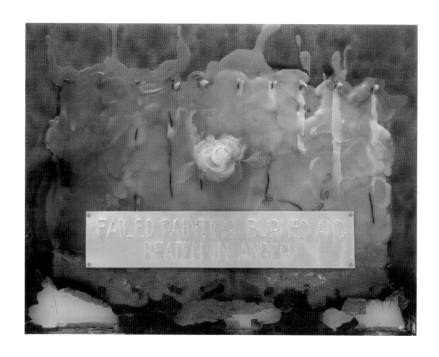

Robert Richenburg, one of the more forceful Abstractionists in New York, explores the conflict between a forbidding repression and a flamboyant sensuality, between masculine will and feminine passion, and between dark and light... [His] abstractions are intense, original and commanding.

Irving Sandler, Art News
1963

Failed Painting Burned and Beaten in Anger, 1967
mixed media, 22 1/2 x 29 inches
Collection of the artist